Flathead
impressions

photography by Chuck Haney

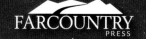

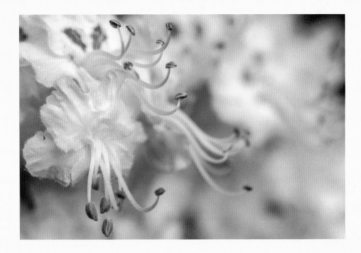

Above: A horse chestnut blooms in spectacular fashion in the Flathead Valley. It's native, however, to Greece and Albania.

Right: A front rolls over Flathead Lake at dusk. From a management perspective, the lake is split in two; the state manages the north half, and the Salish and Kootenai Tribes manage the southern end.

Title page: The Flathead is a verdant valley of lakes, rivers, and streams. Here, Lake Mary Ronan, foreground, and Flathead Lake glow at dusk.

Front cover: A Douglas fir clings to the rocky shoreline at West Shore State Park on Flathead Lake at sunrise. The lake is the largest natural freshwater lake west of the Mississippi.

Back cover: Flathead Lake, at 27 miles long and 15 miles wide, is a great place to explore by sea kayak. Several outfits now rent crafts to visitors.

ISBN: 978-1-56037-736-8

© 2018 by Farcountry Press

Photography © 2018 by Chuck Haney.

For more information about our books, write Farcountry Press, P.O. Box 5630, Helena, MT 59604; call (800) 821-3874; or visit www.farcountrypress.com.

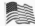 Produced and printed in the United States of America.

22 21 20 19 18 1 2 3 4 5 6

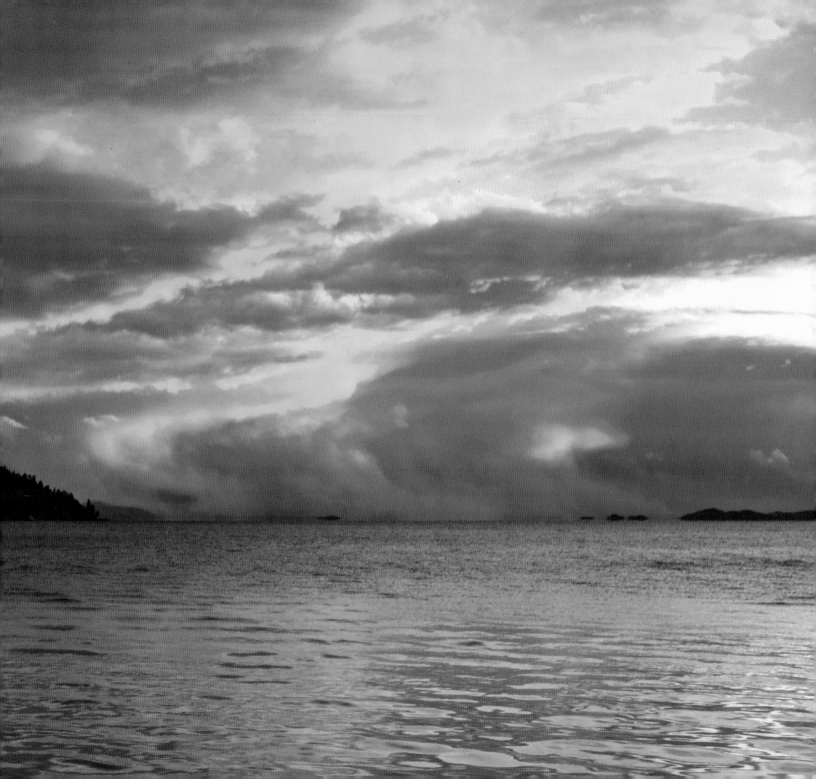

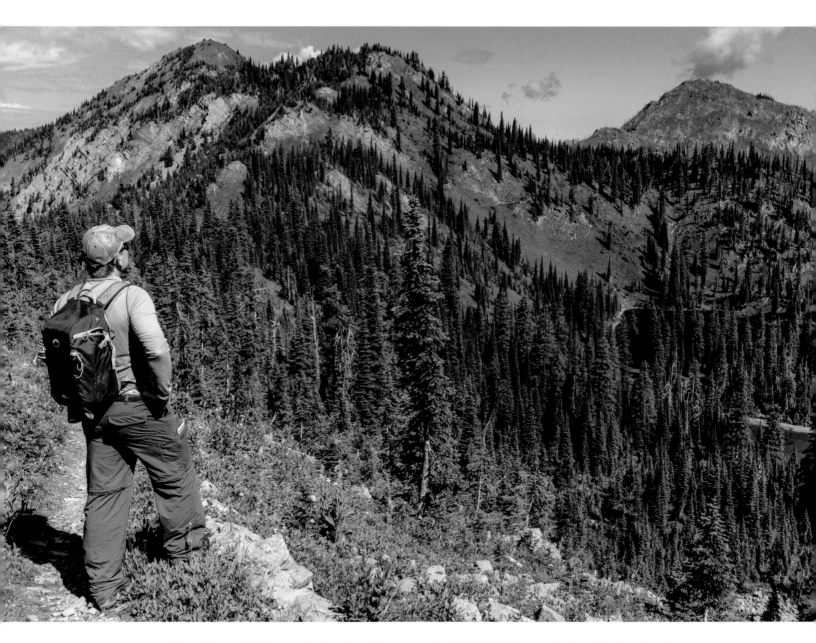

Above: A hiker looks over Picnic Lakes in the Jewel Basin hiking area near Bigfork. The 15,000-plus-acre basin has 27 backcountry lakes, only accessible by foot. No horses or motorized vehicles are allowed on the trails.

Facing page: Crystal clear streams and wildflowers are a trademark of the pristine Jewel.

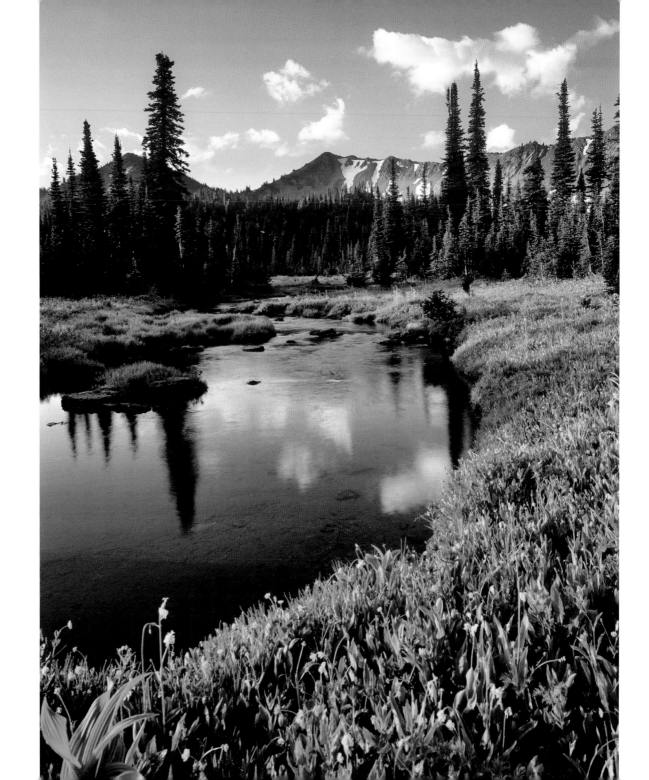

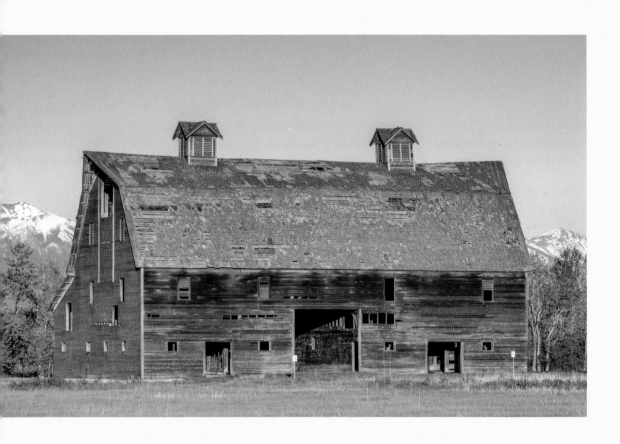

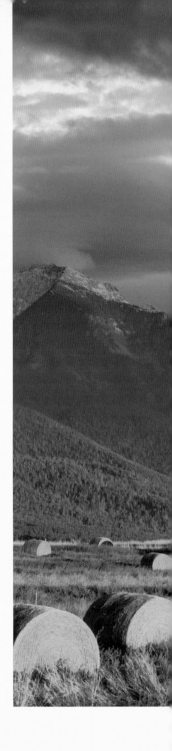

Above: The historic Blasdel Barn was considered one of the largest barns in Flathead County when it was built in 1908 by settler and businessman Frank W. Porter. The barn still stands today on the Blasdel Waterfowl Production Area. It was listed in the National Register of Historic Places in 1999.

Right: The fertile Flathead Valley made excellent farmland for early settlers. Here, longhorn cows and calves graze in a pasture.

Far right: Framed by round bales of hay, this historic barn in the Mission Valley is an iconic reminder of the region's farming and ranching heritage. Even today, the valley is largely farm and ranchland.

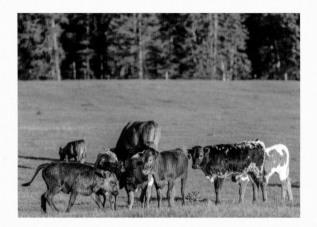

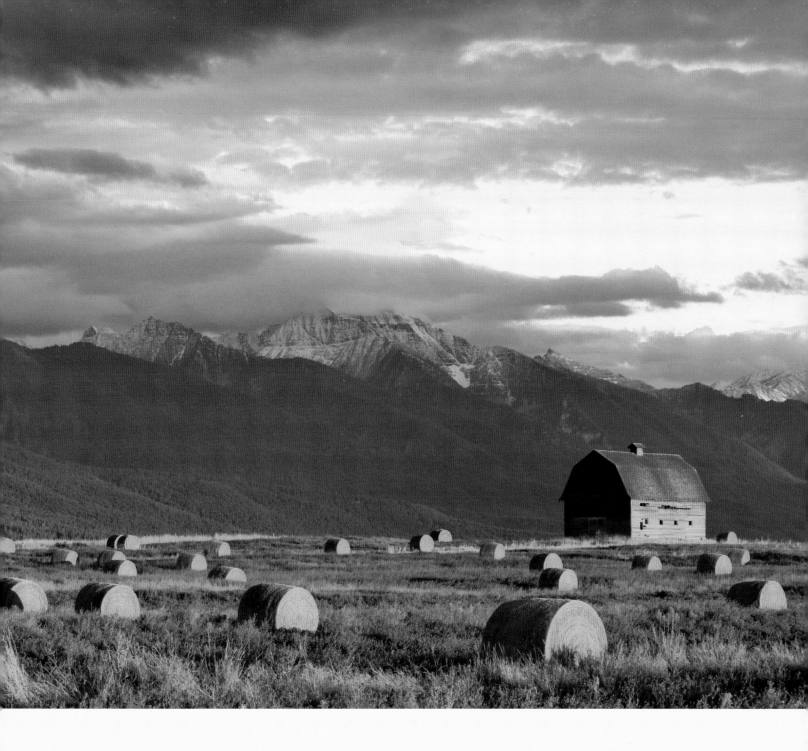

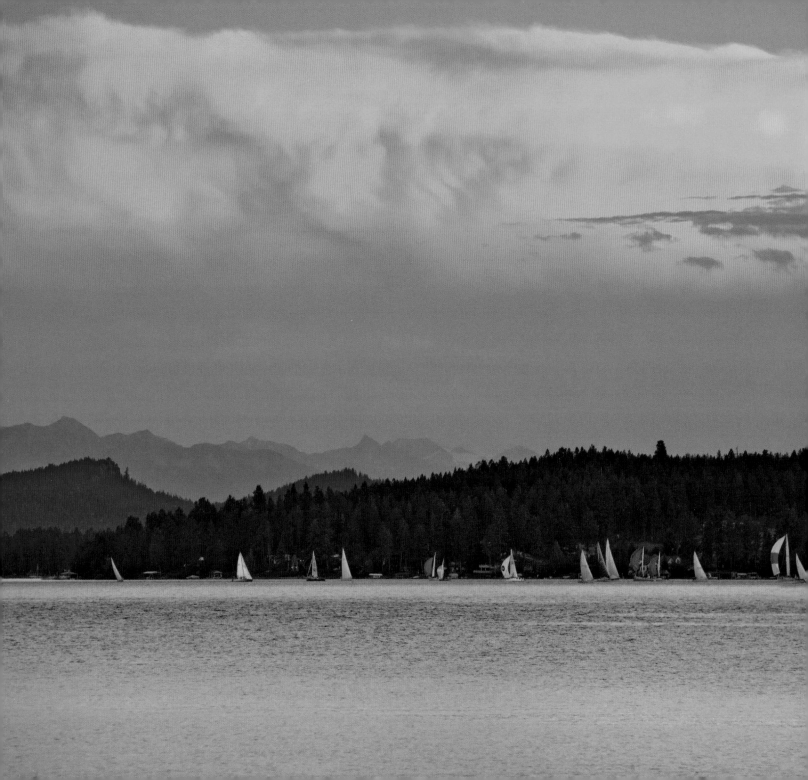

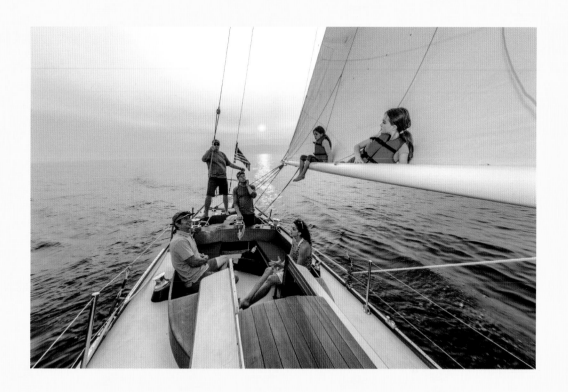

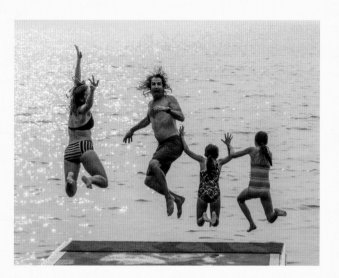

Above: The family crew relaxes on a summer evening sailing on Flathead Lake aboard the Questa, a craft built to racing standards in the America's Cup. Tennyson comes to mind. "So many worlds, so much to do, so little done, such things to be."

Left: Bonsai! There is nothing better than a dip into Flathead Lake on a hot summer day. The lake rarely gets above 70 degrees and is often far colder than that, even in the shallows.

Far left: Sailboats race near Somers on an evening breeze as the clouds above warn of a summer shower yet to fall. Summer rains are typically brief.

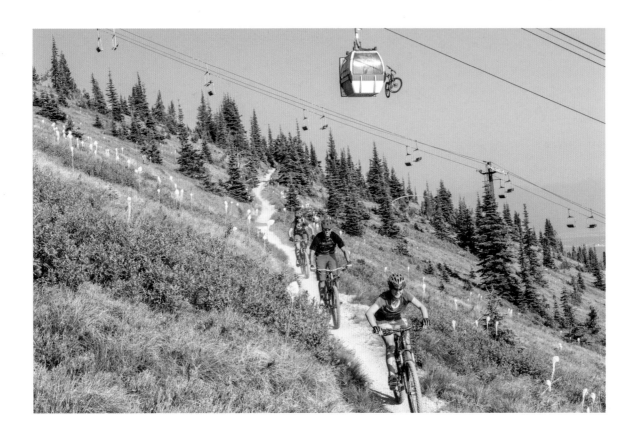

Above: At Whitefish Mountain Resort cyclists take the gondola up and mountain bike back down the trails. The mountain and the surrounding landscape has an extensive bike trail network that courses through the Whitefish Range.

Right: A red fox pup keeps a watchful eye from its den in the Mission Valley. Fox are a common species in the area and often den in the high banks along the river bottoms.

Far right: Bear grass blooms en masse on Big Mountain with the Flathead Valley below. The plant, which is related to lilies, mass blooms every five to ten years.

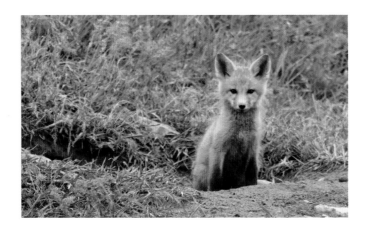

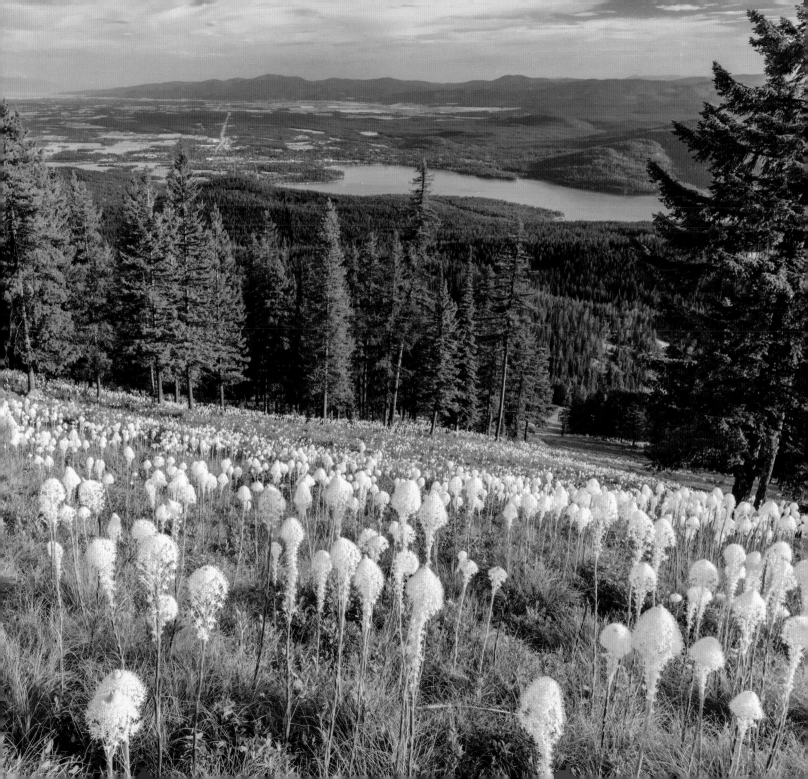

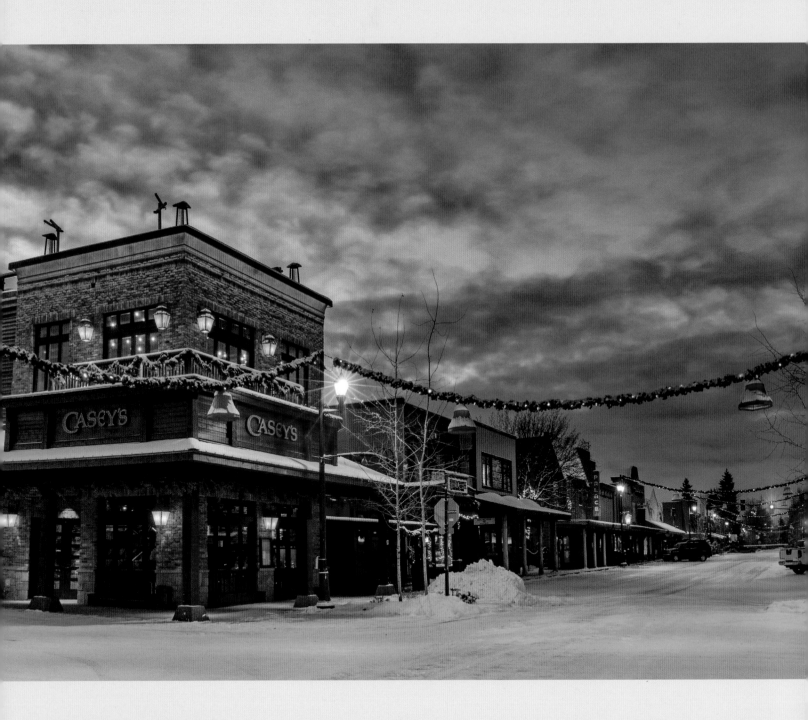

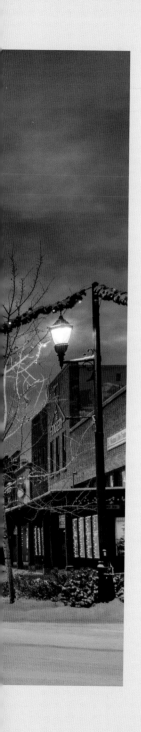

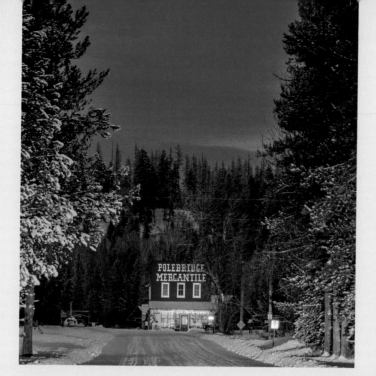

Left: The Polebridge Mercantile, famous for its bakery, glows at Christmastime. Find it up the North Fork of Flathead just outside Glacier National Park.

Far left: Dusted in snow, Central Avenue in Whitefish greets Christmas morning. Whitefish is a year-round destination for eclectic shops, fine restaurants, craft breweries, and art galleries.

Below: Fresh snow makes for a special holiday season in downtown Bigfork. Every Christmas, "elves" (community volunteers) get together to decorate downtown in the quaint village on the east shore of Flathead Lake.

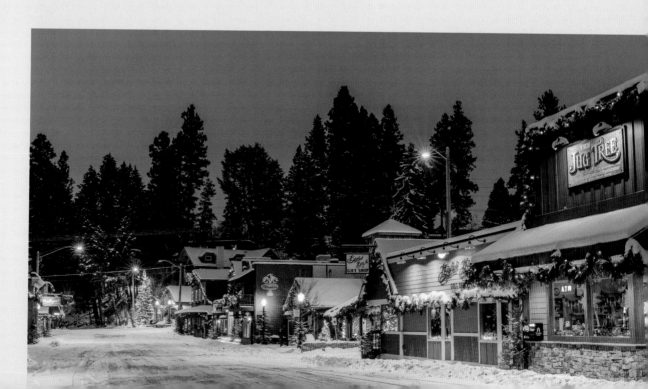

Right: A male lazuli bunting sings from its perch at the National Bison Range in Moiese in the Mission Valley. These colorful birds breed as far north as southern Canada and winter in the Southwest U.S. and Mexico.

Far right: The *Séliš Ksanka Qlispé Dam*, formerly known as the Kerr Dam, is 204 feet high on the Flathead River. Located below Flathead Lake, it generates electrical power and regulates the elevation of the lake.

Below: The Flathead River cuts through dramatic cliffs of clay as it carves its way through the Mission Valley. The landscape is marked by great floods from 10,000 years ago that ran all the way to the Pacific Ocean.

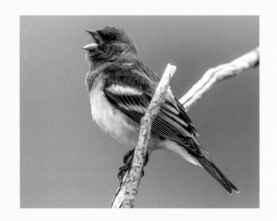

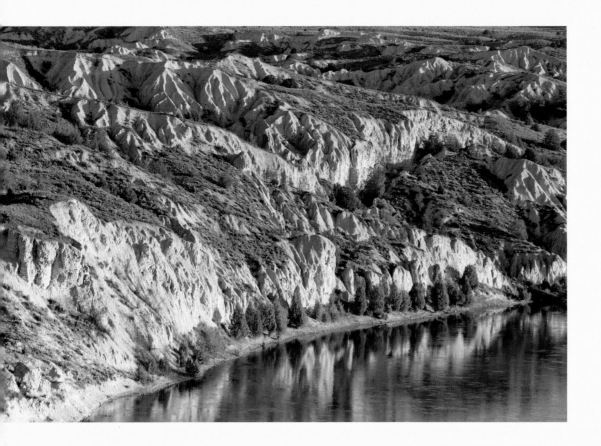

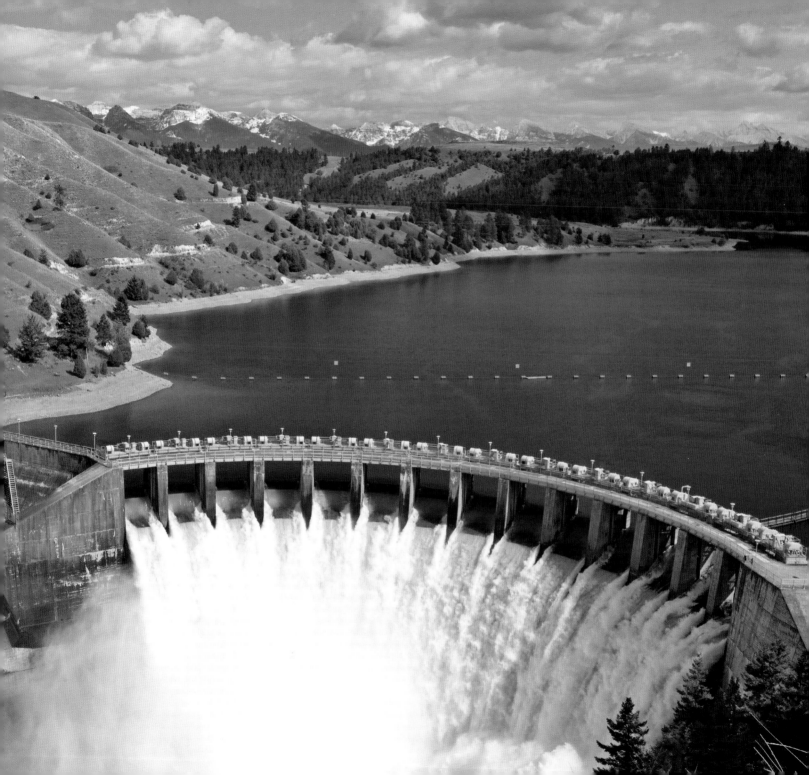

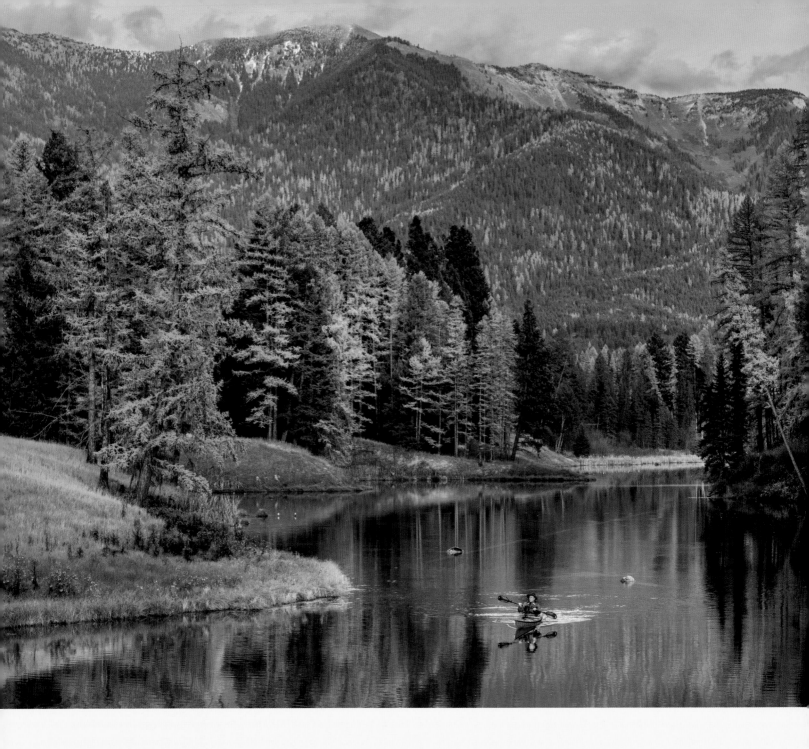

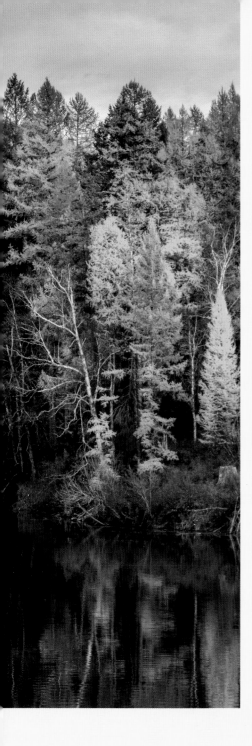

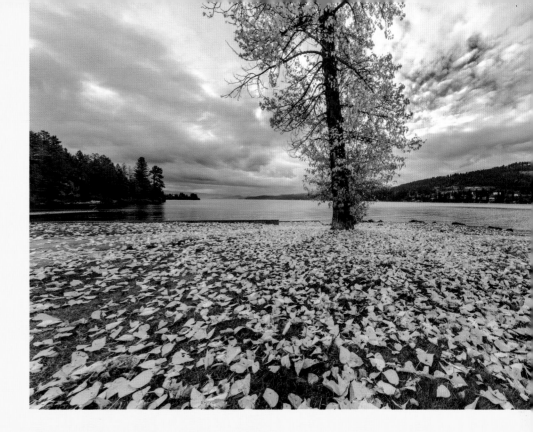

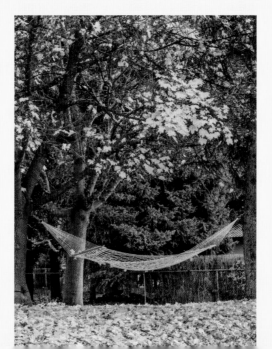

Above: Cottonwoods are a keystone species in the Flathead Valley. The mature trees in particular, with their numerous holes and crags, provide homes for a variety of birds and mammals. Here, one stands guard along the shore of Flathead Lake.

Left: An empty hammock suggests a relaxing nap on a mild fall afternoon.

Far left: Kayaking on Jessup Mill Pond on a pleasant autumn day. The spring-fed pond flows from the Swan Range to feed the Creston Fish Hatchery.

Right: A kayaker makes a turn on the "Wild Mile" of the Swan River at the annual Bigfork Whitewater Festival. The event draws racers from across the globe.

Facing page: The Happy Hippo, a 1967 Vietnam-era amphibious vehicle, rockets into Flathead Lake in Polson. The rig does fun tours on both land and water.

Below: Women raft the Wild and Scenic Middle Fork of the Flathead River. With headwaters on the Bob Marshall Wilderness, the river forms much of the southern boundary of Glacier National Park.

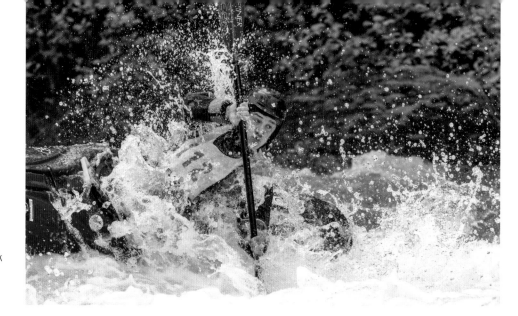

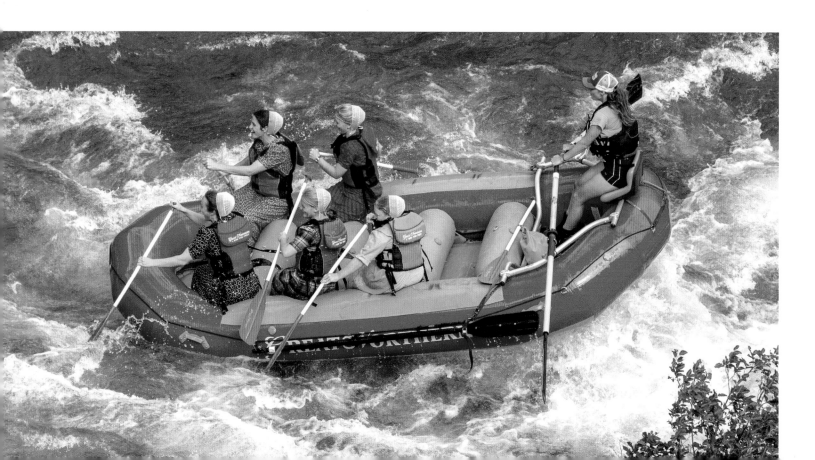

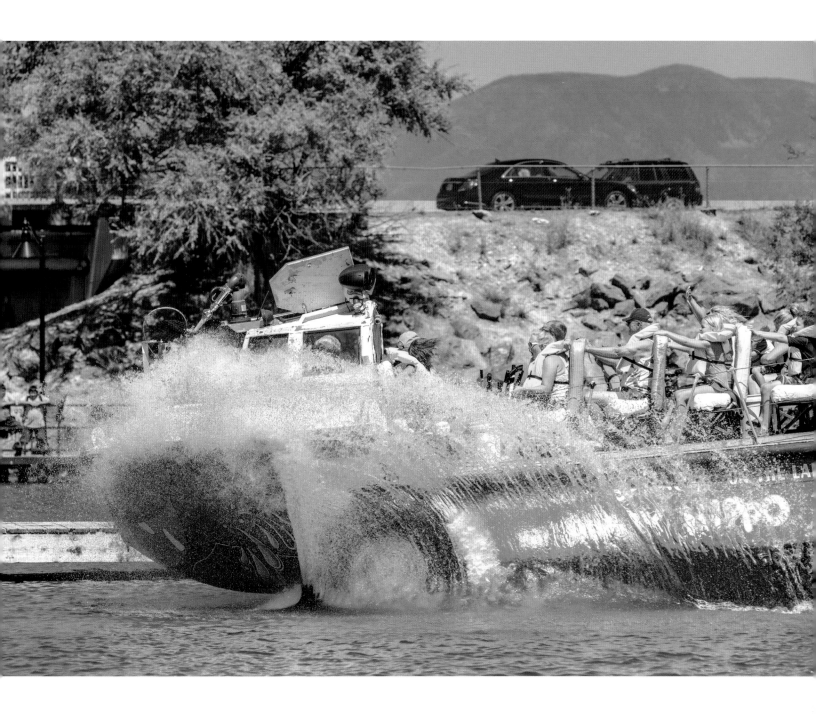

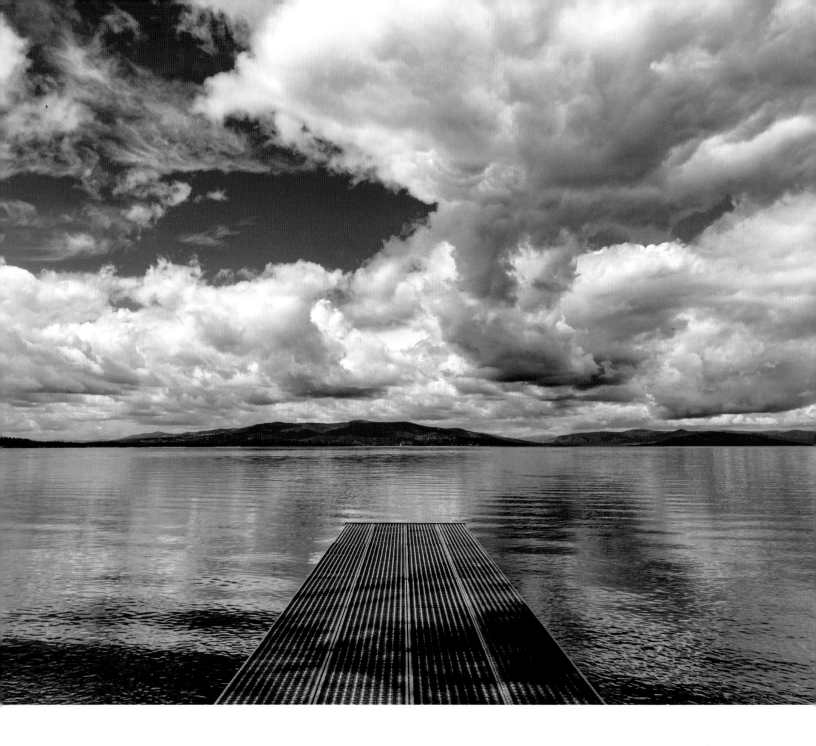

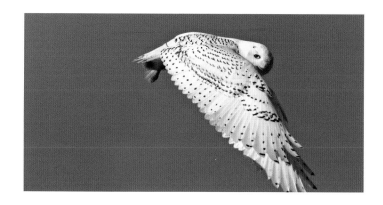

Left: While not common, snowy owls will migrate south to the Flathead Valley in winter months, searching for prey. The birds breed in the Arctic and unlike most owls, hunt during the day as well as night.

Facing page: Clouds skate across the sky as a dock sits empty on Skidoo Bay in Flathead Lake. The bay is just outside Polson on the south end of the lake. The Flathead Watershed is one of the largest most biologically intact watersheds on Earth, with 400 terrestrial wildlife species, including eleven amphibian and eleven reptile species.

Below: Flathead Lake boasts some of the cleanest water in the West. Its water is termed "oligotrophic" meaning it has low levels of nutrients and low densities of plankton. Fish species include about ten native and twenty nonnative.

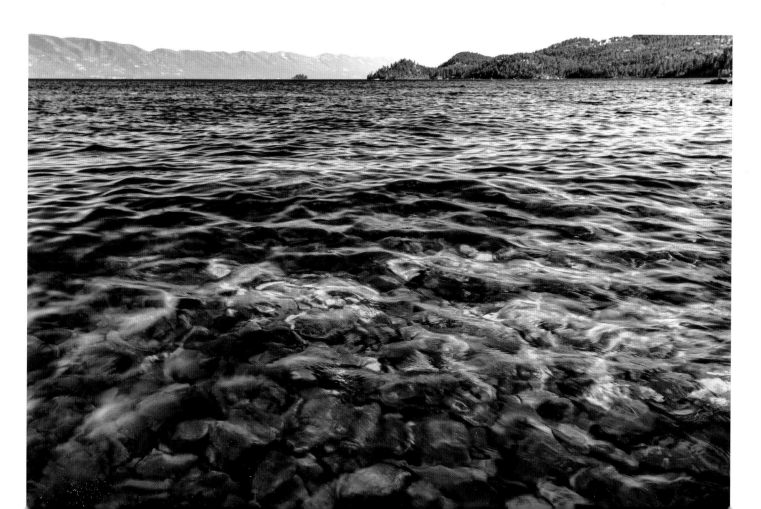

Right: The Flathead Valley has numerous sloughs and backwaters that provide valuable and idyllic wildlife habitat. The valley boasts over 300 bird species on a full or part-time basis.

Below: Sporting a massive set of antlers, a bull moose feeds on lush aquatic vegetation in Glacier National Park. The moose of Montana are shiras moose, the smallest subspecies of moose in North America.

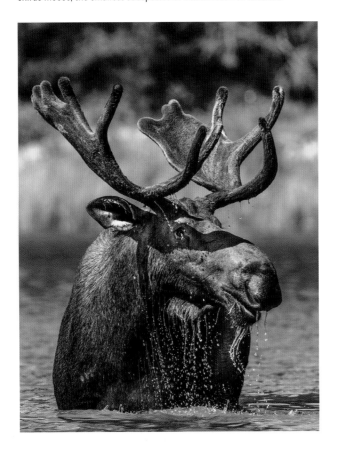

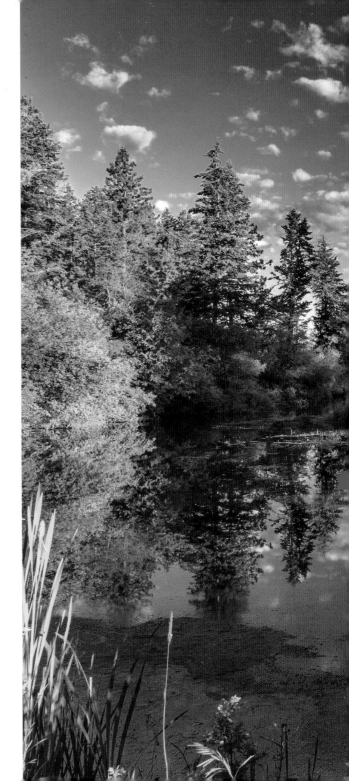

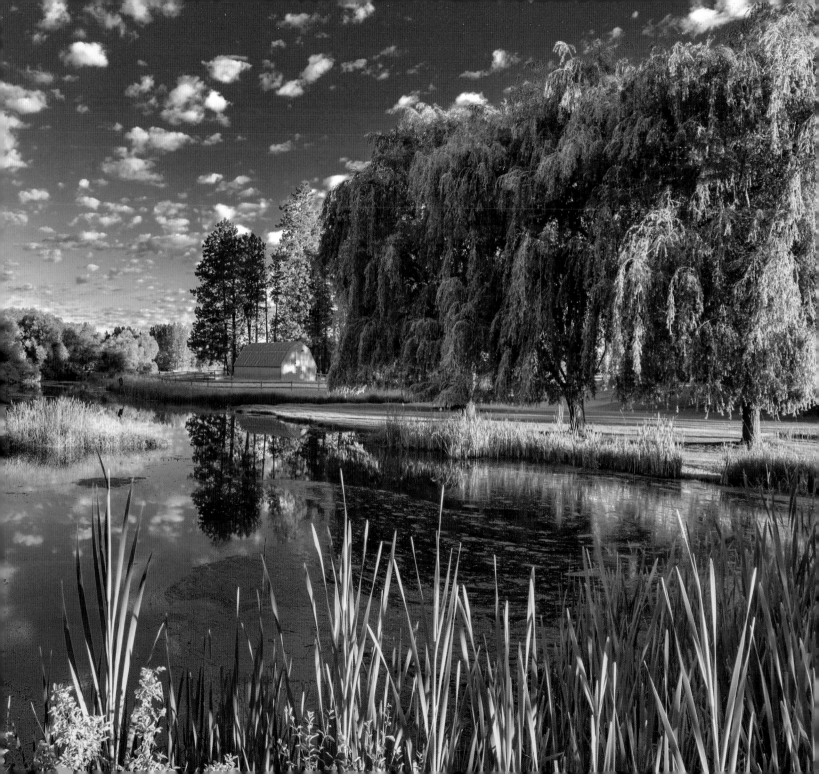

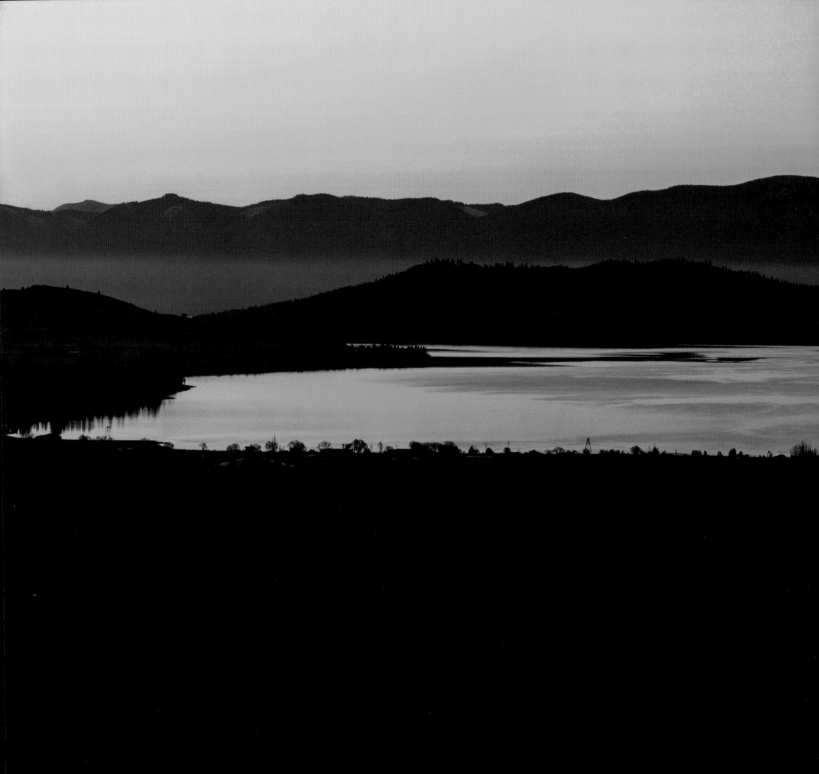

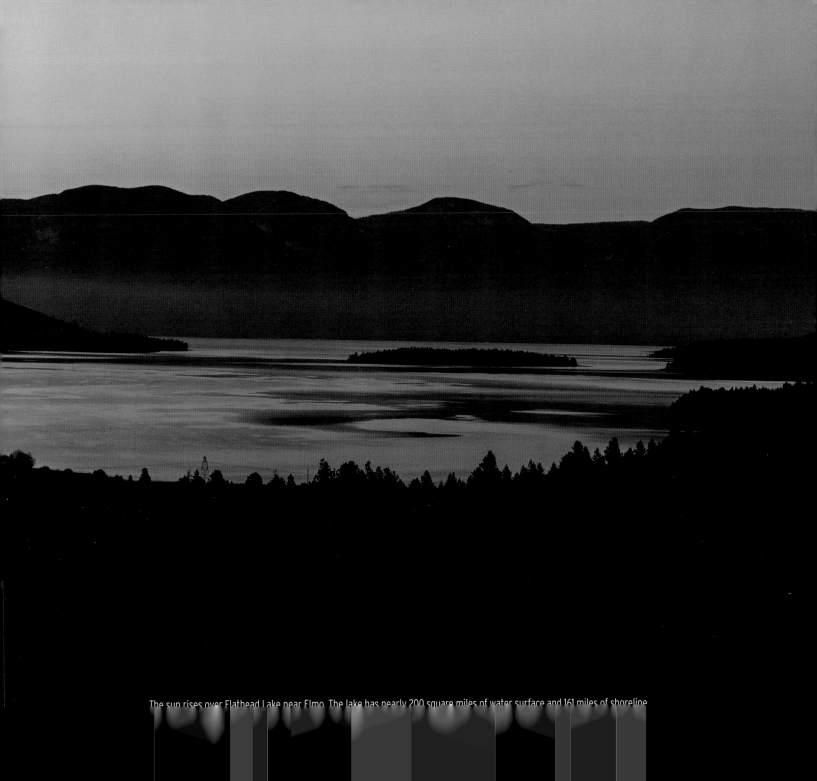

The sun rises over Flathead Lake near Elmo. The lake has nearly 200 square miles of water surface and 161 miles of shoreline.

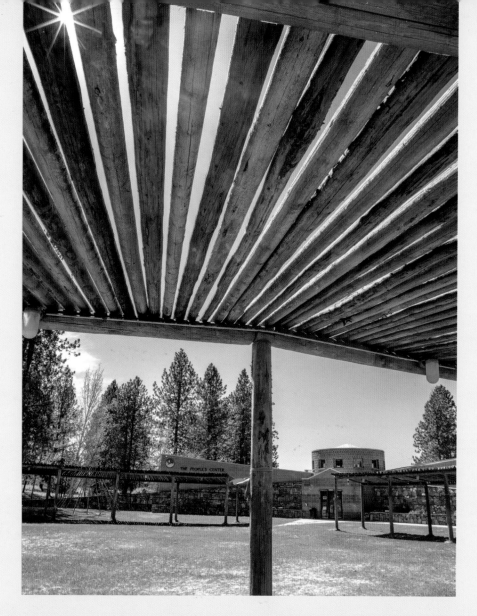

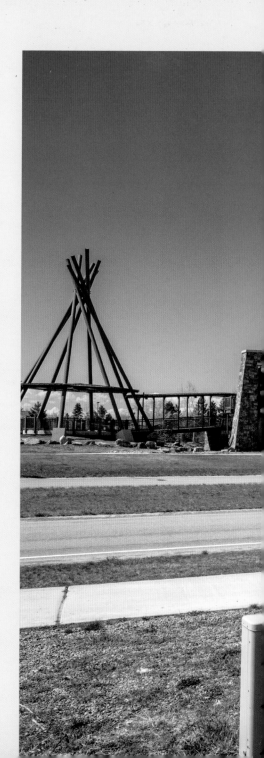

Above: Learn more about the rich cultural heritage and history of the Salish, Pend d''Oreille and Kootenai Tribes at the People's Center *(Sqelixw-Aqlsmaknik)* in Pablo. The center features a museum and educational programs including enchanting oral histories on the Native Americans who lived in the region for thousands of years.

Right: Completed in 2013, the 265-foot Pablo Pedestrian Bridge, connects the Confederated Salish and Kootenai Tribal headquarters with the Salish Kootenai College over U.S. Highway 93. Two steel tepees on either side of the bridge symbolize the two tribes in co-existence.

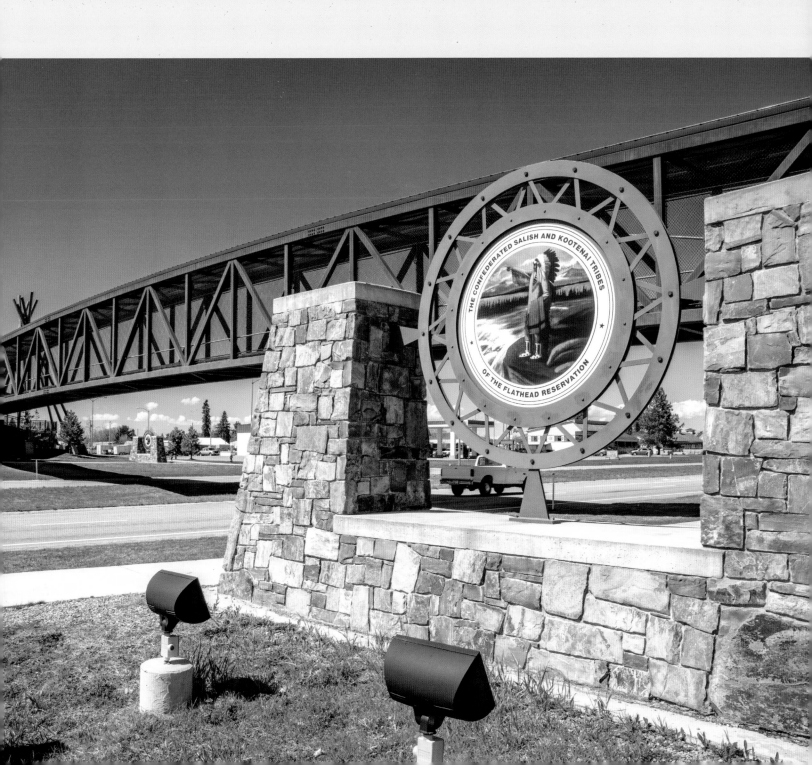

THE CONFEDERATED SALISH AND KOOTENAI TRIBES

OF THE FLATHEAD RESERVATION

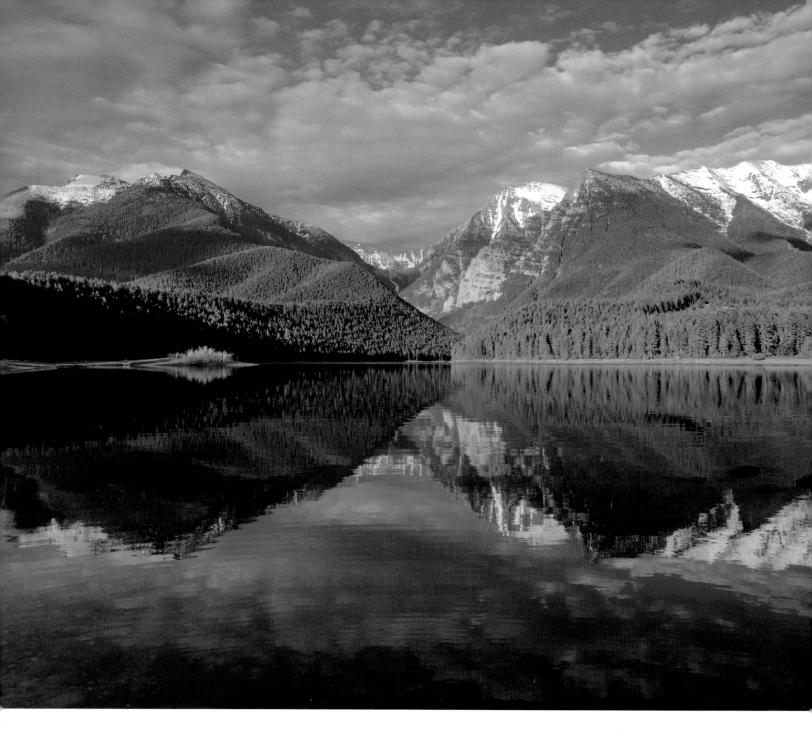

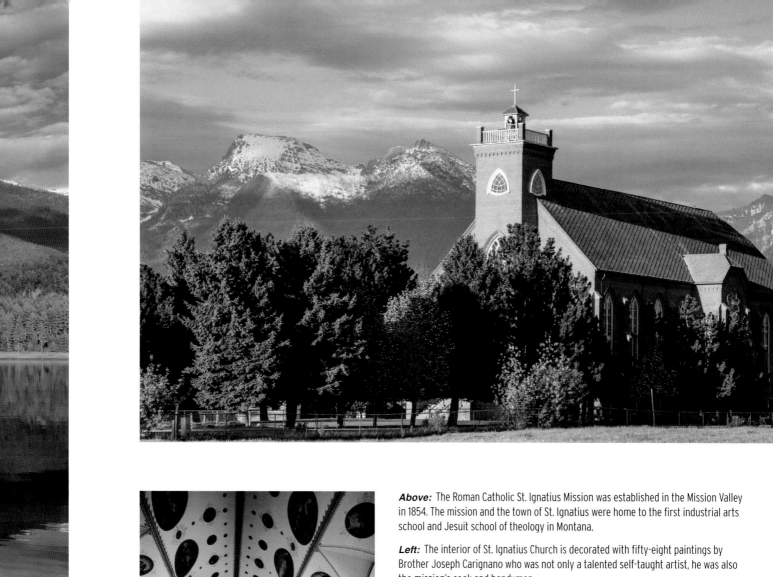

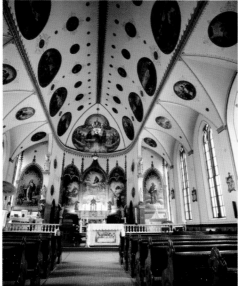

Above: The Roman Catholic St. Ignatius Mission was established in the Mission Valley in 1854. The mission and the town of St. Ignatius were home to the first industrial arts school and Jesuit school of theology in Montana.

Left: The interior of St. Ignatius Church is decorated with fifty-eight paintings by Brother Joseph Carignano who was not only a talented self-taught artist, he was also the mission's cook and handyman.

Far left: See the reflections of the high peaks of the Mission Mountain Wilderness near St. Ignatius in the Mission Reservoir. There are few trails in the wilderness and some areas are closed entirely for months in the summer to protect foraging grizzly bears.

Right: The Great Northern Rails to Trails gives cyclists and pedestrians a 22-mile route across the Flathead Valley from Somers on the north shore of Flathead Lake west to Kila.

Far right: Western larch glow gold along the Hungry Horse Reservoir. The fire-resistant species is coveted for lumber and firewood; these trees lose their needles in the fall.

Below: Autumn is a great time to fly fish the Middle Fork of the Flathead River as the river changes personality from rambling whitewater to placid trout stream. The Middle Fork was the inspiration for the creation of the Wild and Scenic River Act, which protects free-flowing streams across the United States.

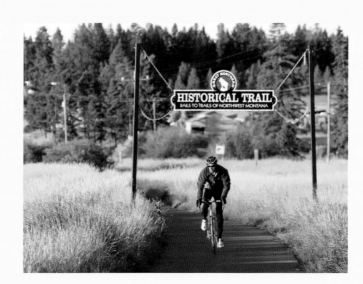

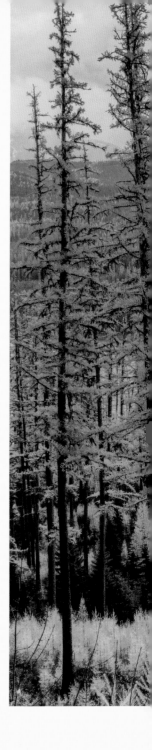

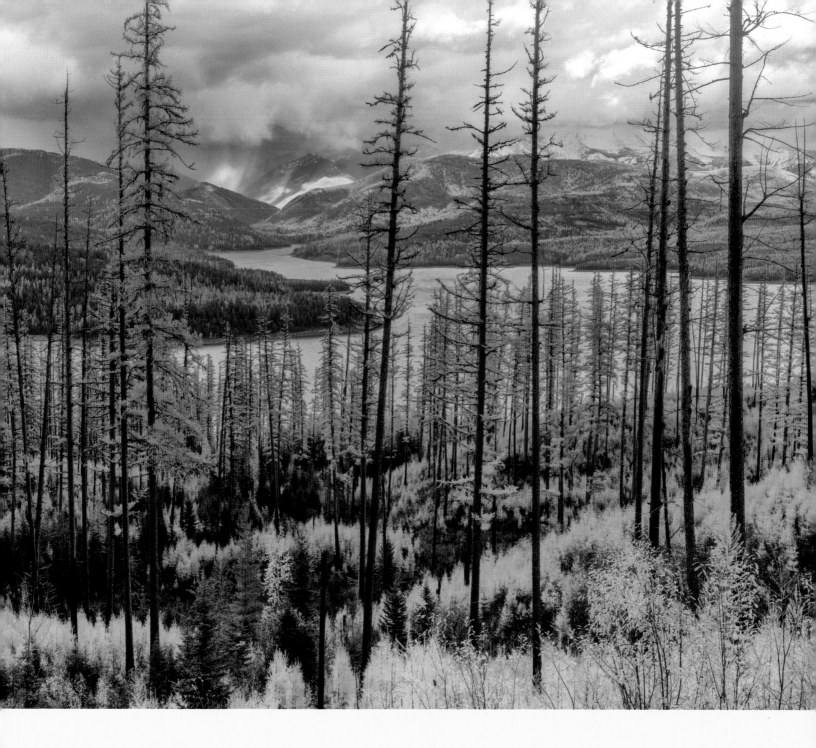

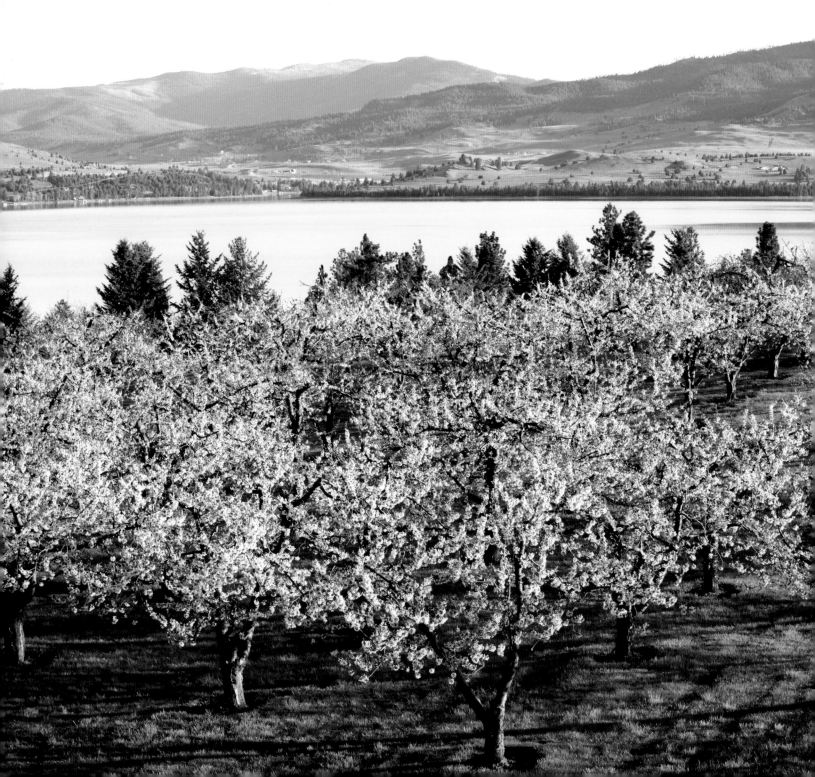

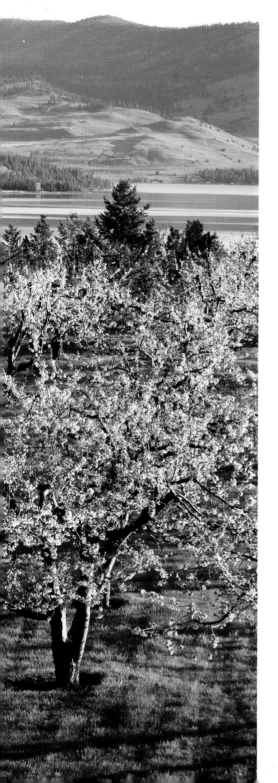

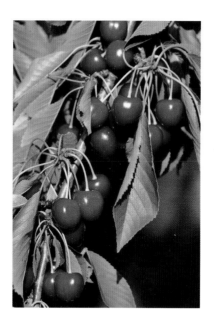

Left: Ripe Flathead cherries are a coveted snack in the summer months. There are about 100 commercial cherry growers in the Flathead Valley and they produce between three to five million pounds of cherries each season.

Far left: A cherry orchard blooms along Flathead Lake. The climate along the lake is ideal for growing some of the best cherries in the world.

Below: A cherry stand along Flathead Lake is a familiar sight.

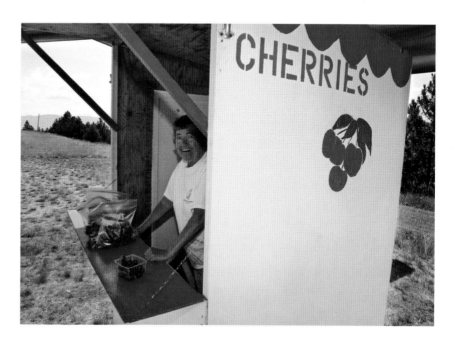

Right: Yee-ha! The Flathead is rodeo country in the summertime. Here a rider tries to stay on this bucking bronc for eight seconds without that free hand touching the horse.

Far right: Framed by the Whitefish Range, horses graze in the evening light. After a long winter, spring rains turn the grass to a bright green.

Below: Ten feet in the air on the back of a horse? Why not? The Event at Rebecca Farm just west of Kalispell features some of the best competitors in the world in cross-country and dressage.

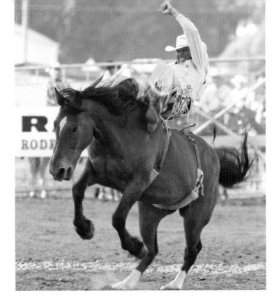

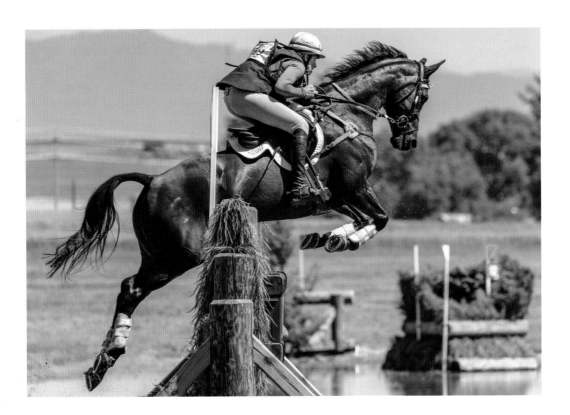

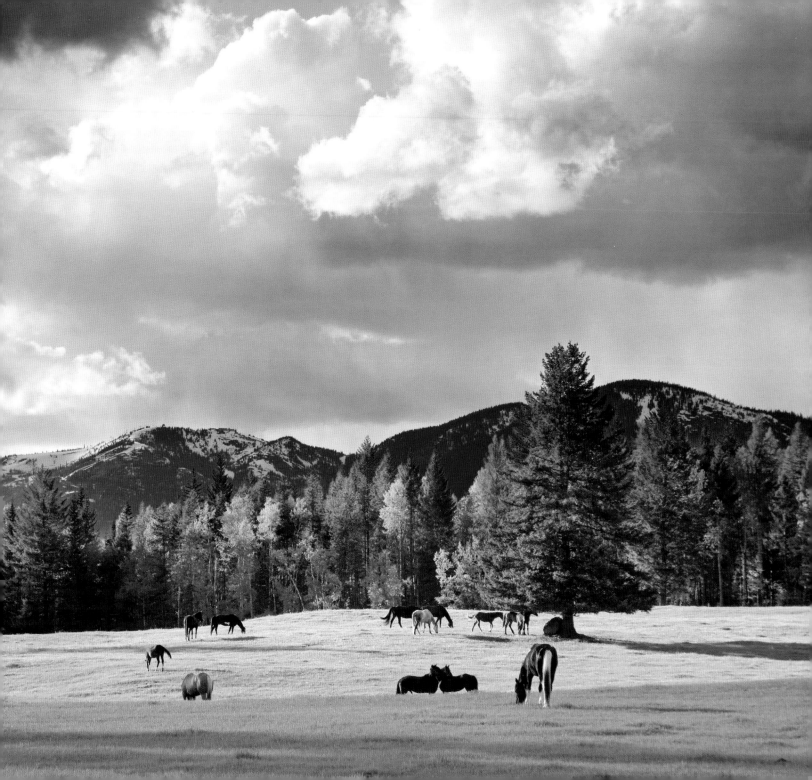

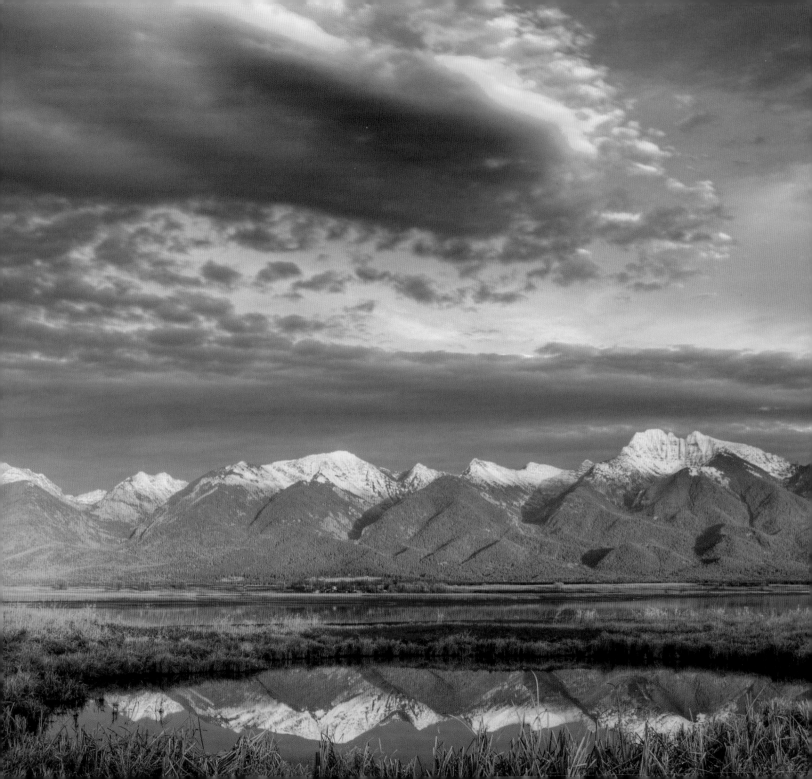

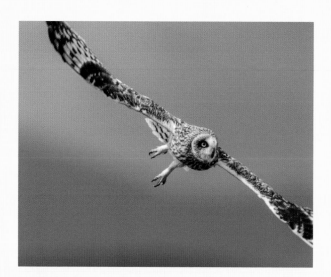

Left: A short-eared owl takes wing at the Ninepipe Wildlife Management Area in the Mission Valley. Short-eared owls are a ground nester and are one of the few owl species to make their own nest.

Far left: The snow-capped Mission Range reflects into a pond on the 3,000-acre Ninepipe Wildlife Management Area, which provides valuable waterfowl and bird habitat. In the hills, approximately 113 lakes greater than one acre in size can be found in the cirque basins created by the glaciers that formed the landscape.

Below: White pelicans and a lone double-crested cormorant take a break on a rock pile in the Mission Valley. Thousands of acres in the valley have state, federal, and tribal protections to preserve valuable habitat.

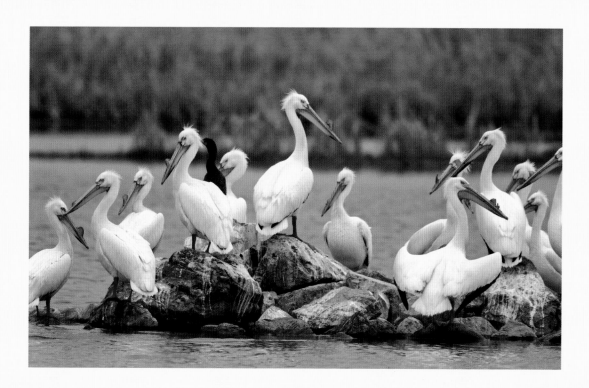

Right: Beets, carrots, and rhubarb are just some of the produce grown in the Flathead's rich soils and sold at local farmer's markets.

Far right: Bright yellow canola flowers blanket fields in the valley every summer. Canola is used to make cooking oil.

Below: A modest pumpkin patch produces a wagon load of pumpkins on a farm near Kalispell. Pumpkins are actually considered a fruit, because they come from the seed-bearing part of the plant. They make excellent pies and muffins.

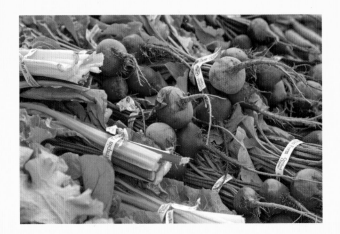

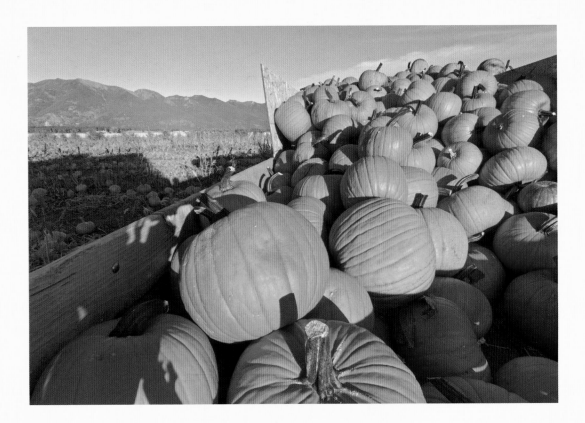

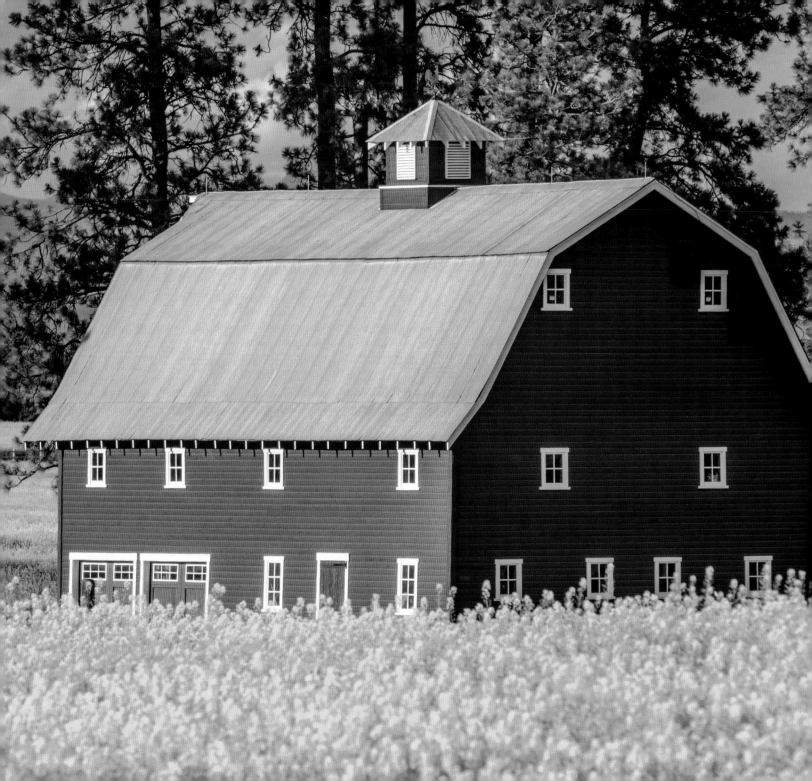

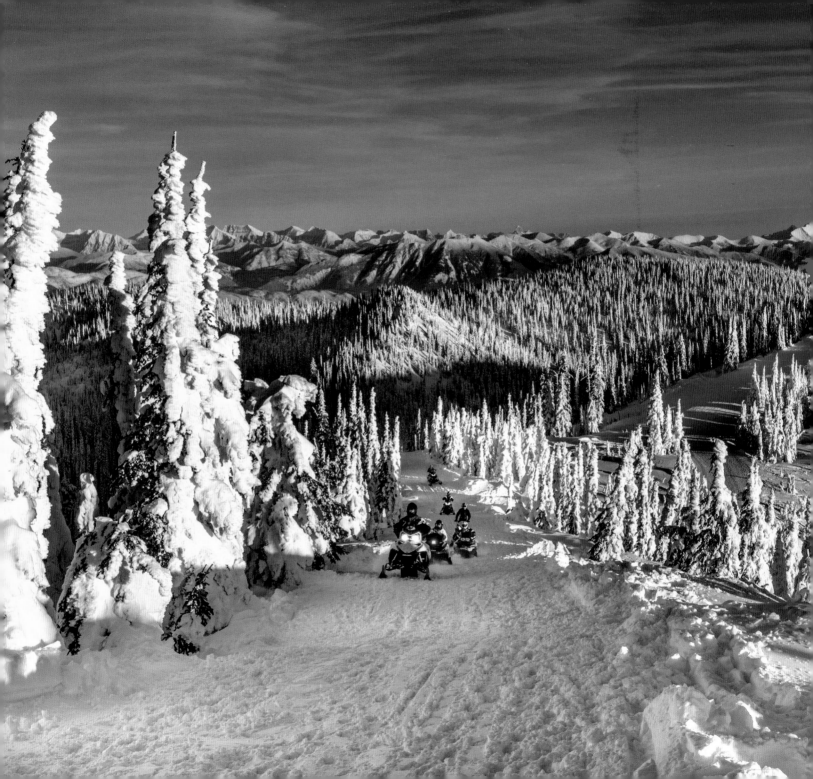

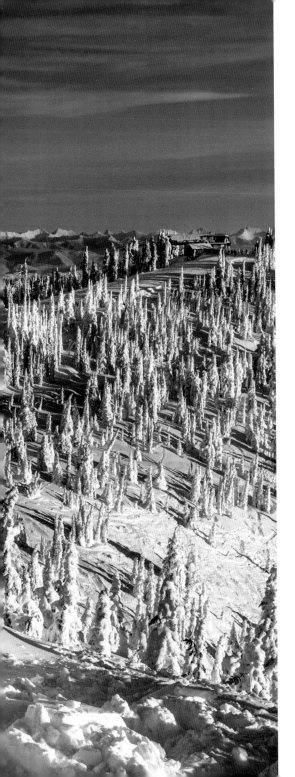

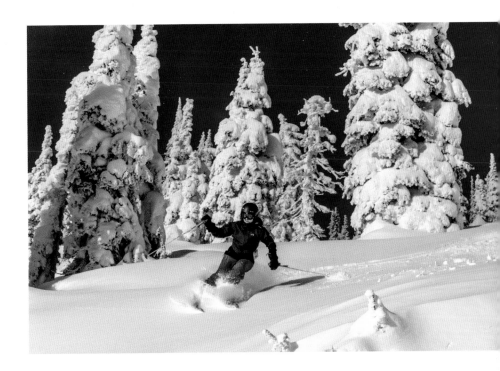

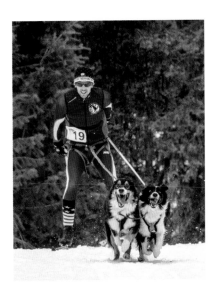

Above: Carving a turn in fresh powder at Whitefish Mountain Resort. When ice coats the trees, they're called snow ghosts.

Left: A skijorer and his team compete in the Flathead Classic Sled Dog Race. The Flathead Valley sees big swings in average snowfall, from about 38 inches near Flathead Lake to 116 inches in West Glacier and more than 400 inches in the mountainous terrain during heavy snow years.

Far left: Snowmobilers near the summit of Whitefish Mountain Resort (aka Big Mountain) in the Whitefish Range. The Flathead Snowmobile Association grooms and maintains more than 200 miles of trails in the region every winter.

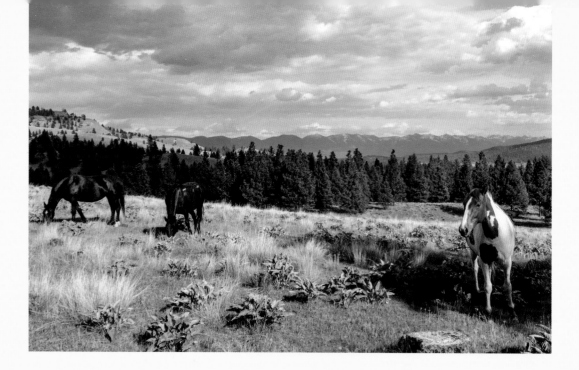

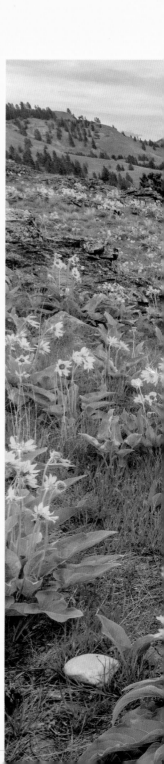

Above: Horses graze on Wildhorse Island State Park. The Salish and Kootenai tribes were said to hide horses on the island to keep them from being stolen. Today, just a handful of horses live there.

Right: Bighorn sheep are more common on the island today. Here, a ewe looks over Flathead Lake from a cliff. The target population for sheep on the island is about 100. The state, at times, will capture excess sheep and move them to other habitats in the state.

Far right: Wildhorse Island is only accessible by boat. In the spring, abundant gardens of native arrowleaf balsamroot bloom on the island.

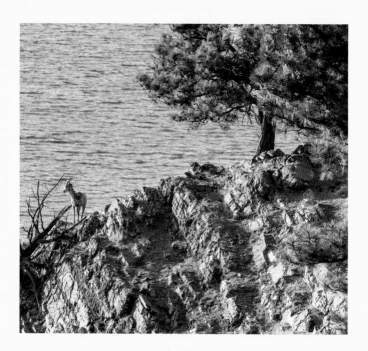

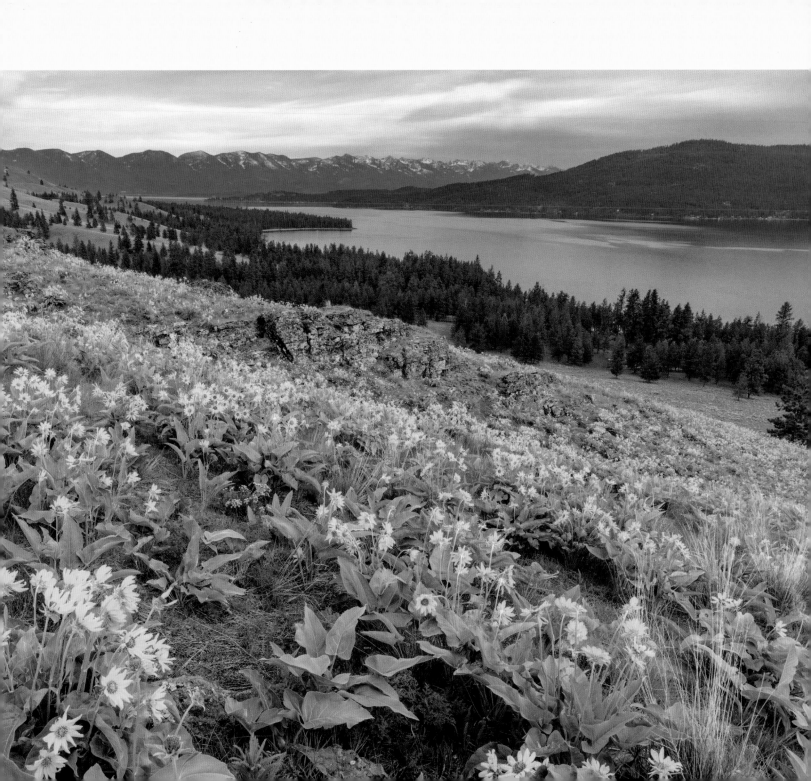

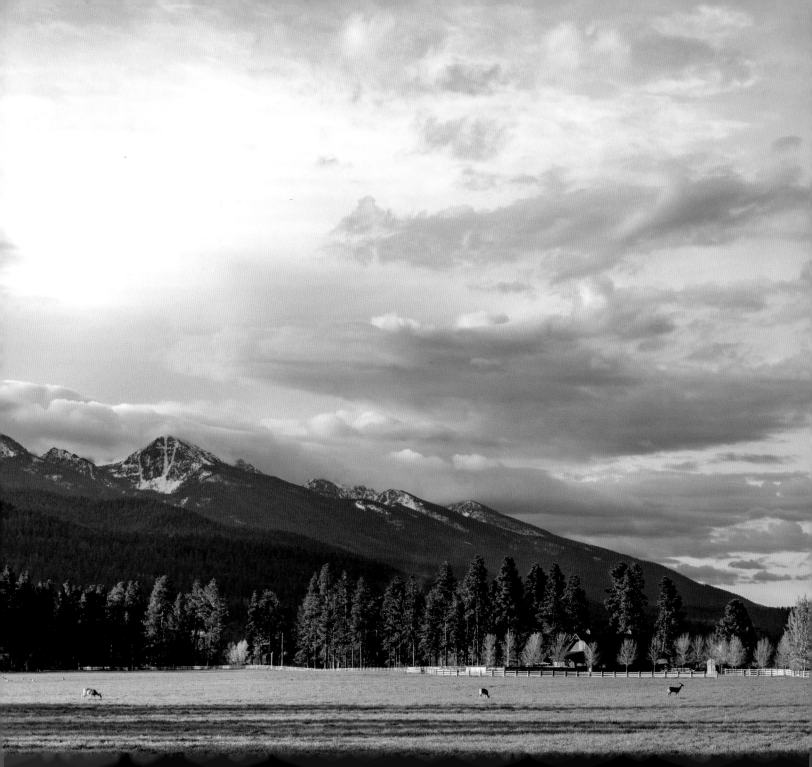

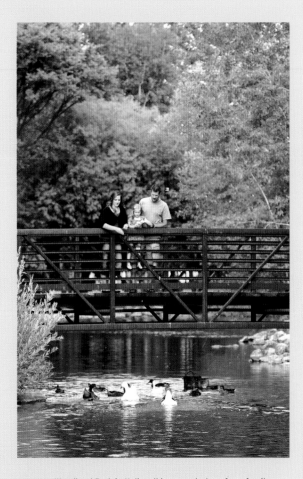

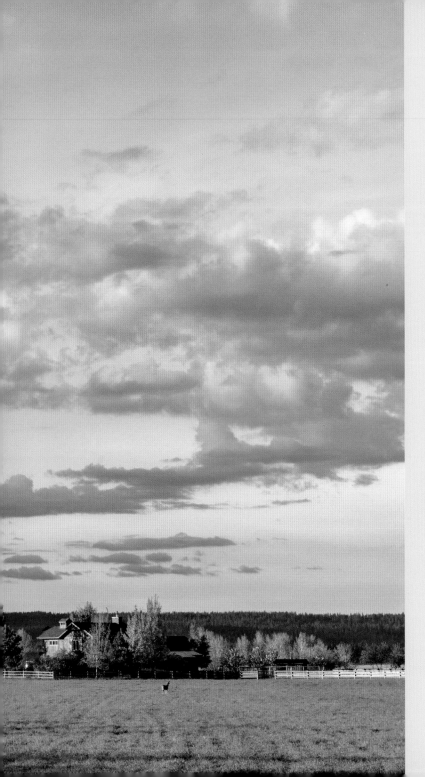

Above: Woodland Park in Kalispell is a great place for a family outing. The Park also features a pool and water park, a skating rink, and a duck pond, shown here, with dozens of domestic ducks and geese.

Left: Whitetail deer feed in a field in the Flathead Valley. Whitetail and mule deer are the most widely distributed big game in Montana. In the Flathead, whitetails are more common in the valley floor; mulies are typically found in the higher terrain.

Right: This dusky grouse was a bit soggy after a shower at the National Bison Range. It's one of the largest grouse species in North America.

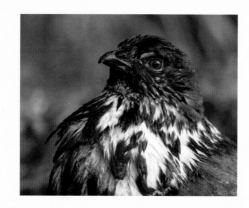

Far right: Doris Creek runs toward the Hungry Horse Reservoir. The 34-mile-long reservoir is created by the Hungry Horse Dam on the South Fork of the Flathead River.

Below: A male grizzly bear checks the air in Glacier National Park. The park is home to both black and grizzly bears. It has about 300 grizzlies roaming its one million acres.

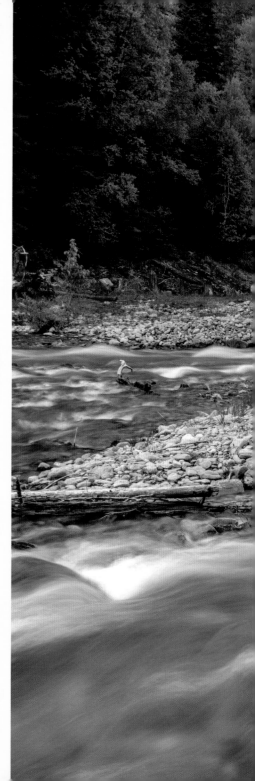

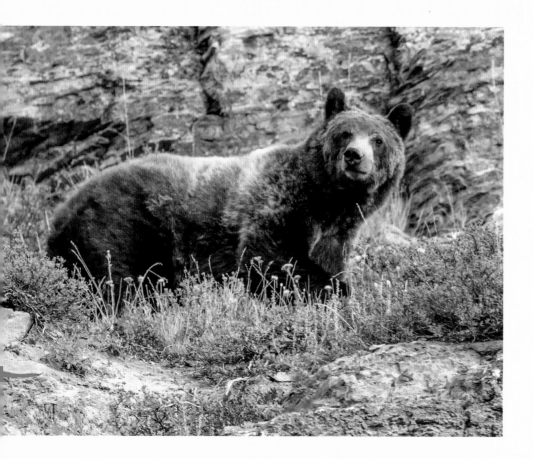

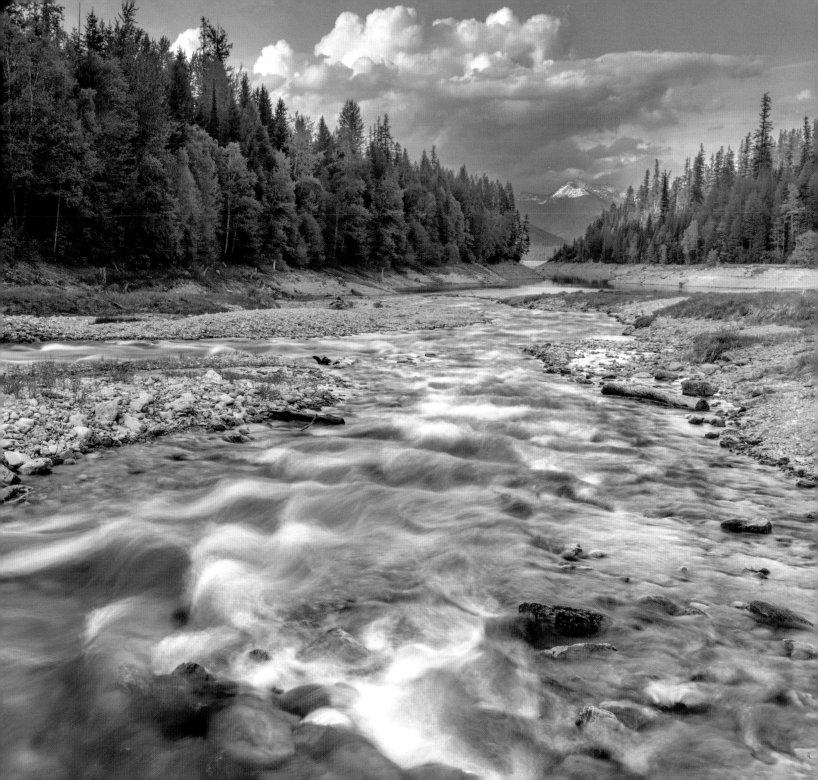

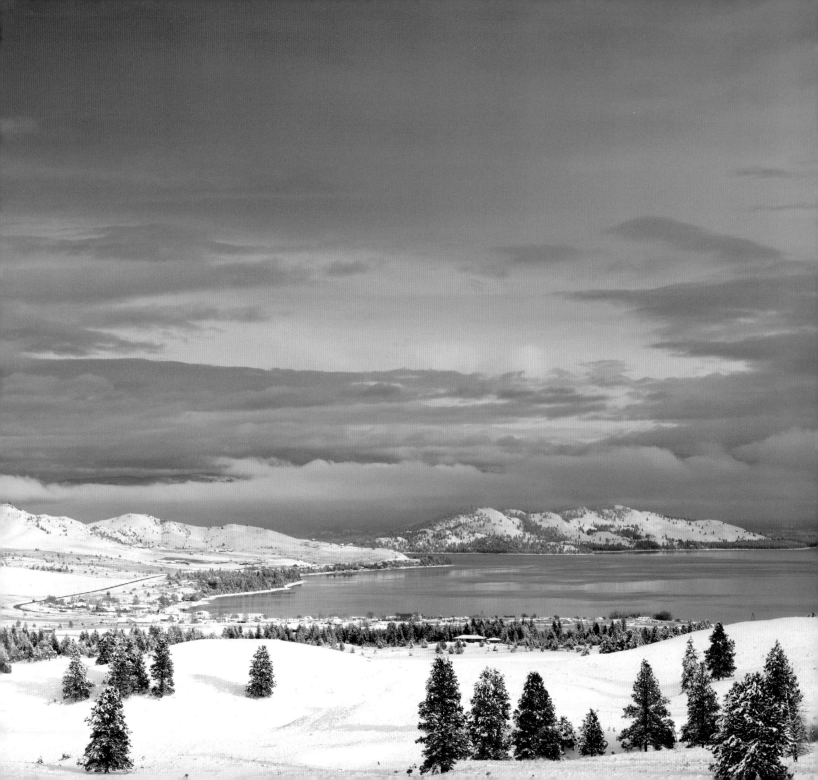

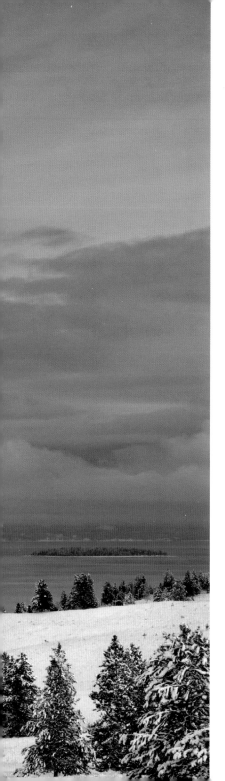

Left: The annual Bar Stool Races down Sugar Hill in Martin City are a great way to beat the winter blues each February. The races are more fun than competition and are fueled by plenty of adult beverages.

Far left: Fresh snow blankets the shores of Flathead Lake. The lake is big enough to create its own weather and "lake effect" snow is not uncommon in the winter months, when cold air rides over the warm waters of the lake.

Below: Getting around the old-fashioned way at the Bar W Ranch in a horse-drawn sleigh. The horse is still a utility animal on many Montana ranches.

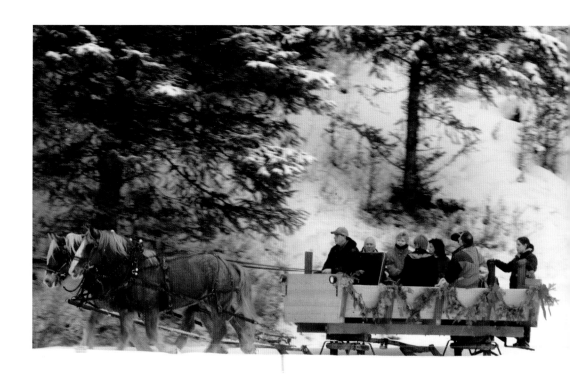

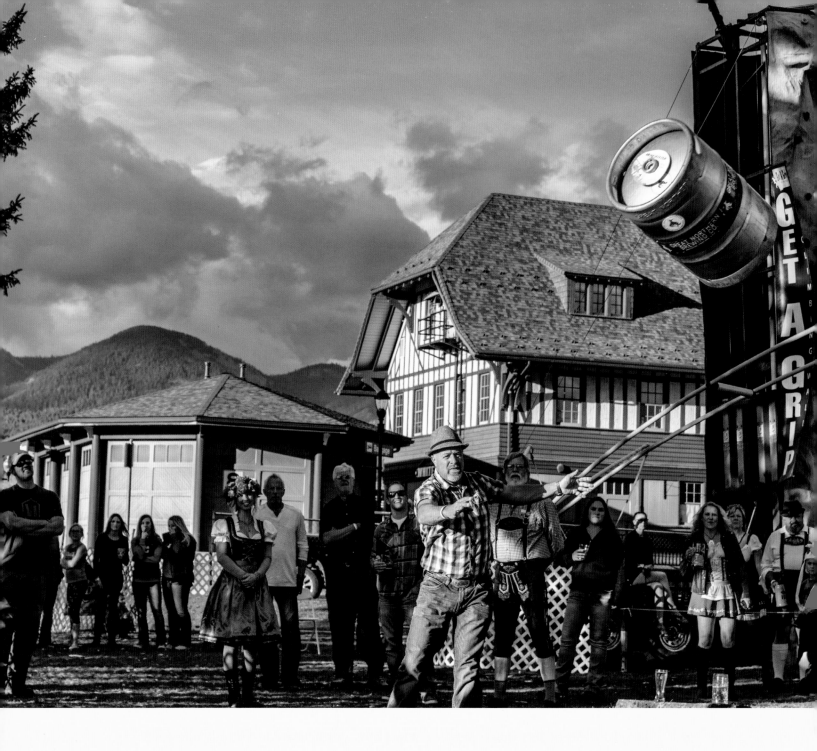

Far left: Keg tossing is just one of the fun competitions at the Great Northwest Oktoberfest in Whitefish. Other competitions include stein holding, log sawing and a kid's chicken dance.

Left: The competition isn't just for men. The event also features authentic German music and food, including elk bratwurst, definitely a Montana touch.

Below: Polkas and other German dances showcase the two-week event. There's also plenty of beer, including German-inspired brews crafted here in Montana and imports from Germany and Austria.

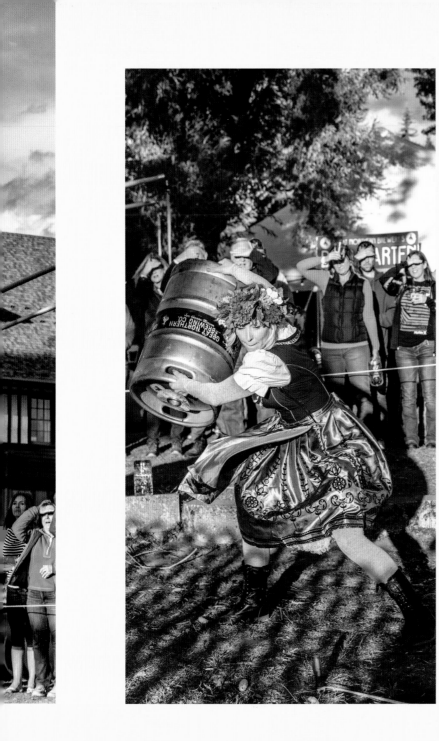

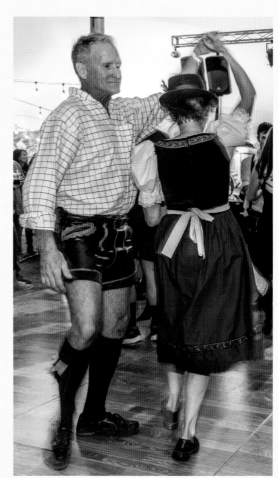

Right: The Conrad Mansion, the former home of Charles E. Conrad and his family, is a museum today. Conrad was one of the founding fathers of the city of Kalispell in the 1890s.

Facing page: In the center of Kalispell is the historic Flathead County Courthouse. Built in 1902, it's still in use today.

Below: The Hockaday Museum of Art is the valley's premier art museum, featuring the works of Montana artists with permanent exhibits on the art of Glacier National Park. The museum is named after former Lakeside artist, Hugh Hockaday.

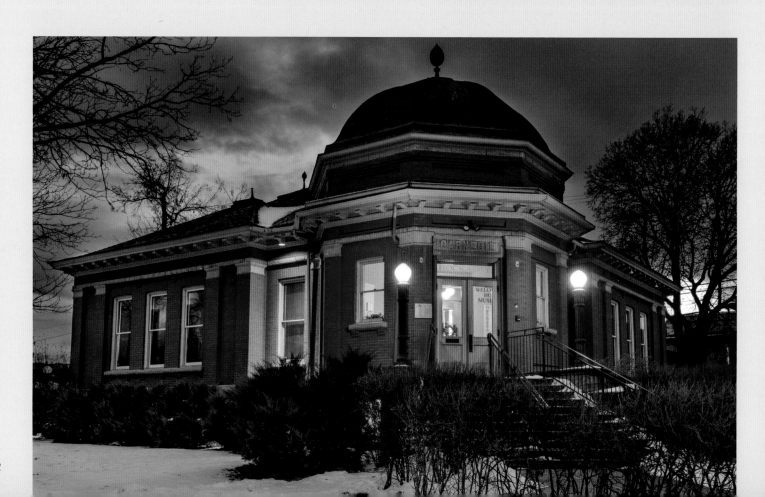

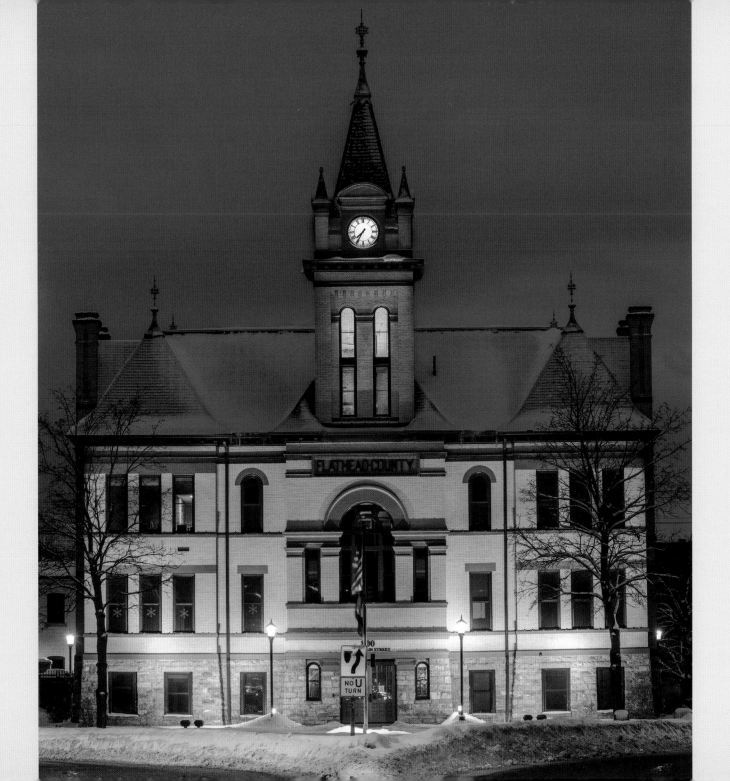

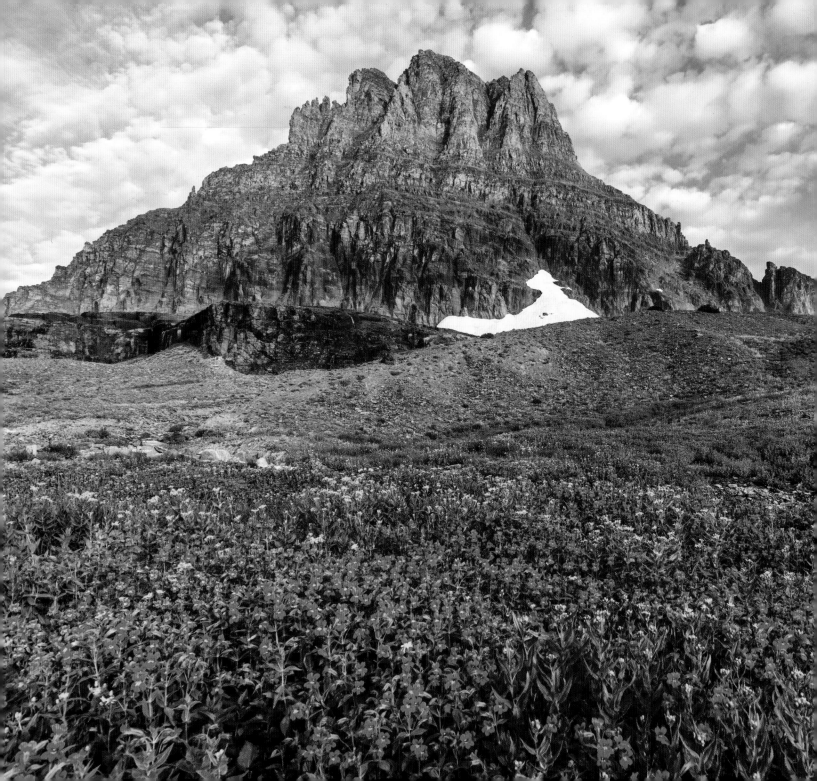

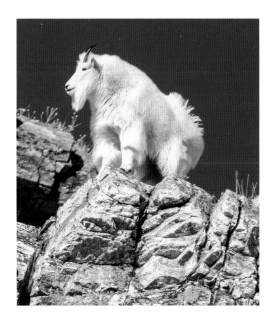

Left: Sporting a thick coat, this billy mountain goat is ready for winter in Glacier National Park. A billy can weigh up to 250 pounds.

Far left: The crown jewel of the Flathead Valley is Glacier National Park. Here Lewis's monkeyflower blooms at Logan Pass as Mount Clements reaches skyward.

Below: Cold, clean water flows toward the Flathead Valley from Avalanche Creek in Glacier National Park. The Park provides the valley with some of the cleanest water in the world.

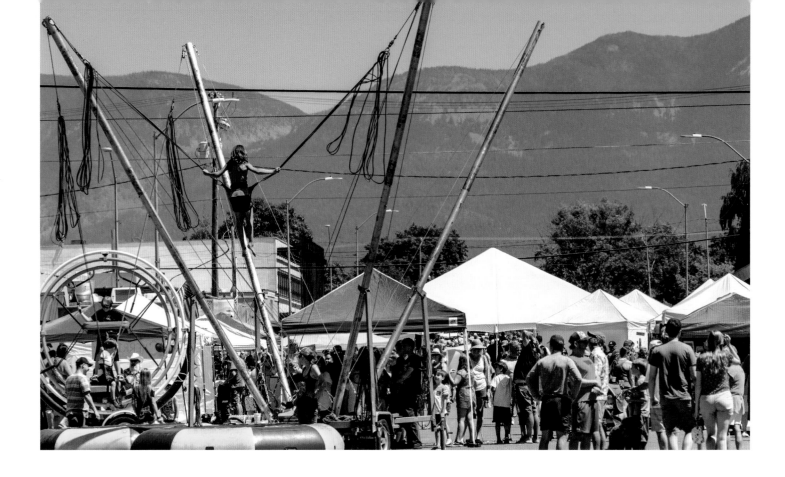

Above: Polson celebrates its lake orchards with a cherry festival each summer. Cherry trees were first introduced to Montana in the 1860s.

Right: What's a cherry festival without a hands-free cherry pie eating contest? The festival also features a cherry pit spitting contest to see who can spit a pit the farthest.

Far right: A Flathead Cherry Festival mural brightens up a building in downtown Polson. The region's cherry heritage dates back to the 1930s, when the first commercial cherries were shipped from the valley.

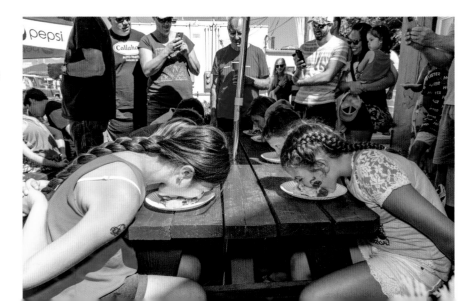

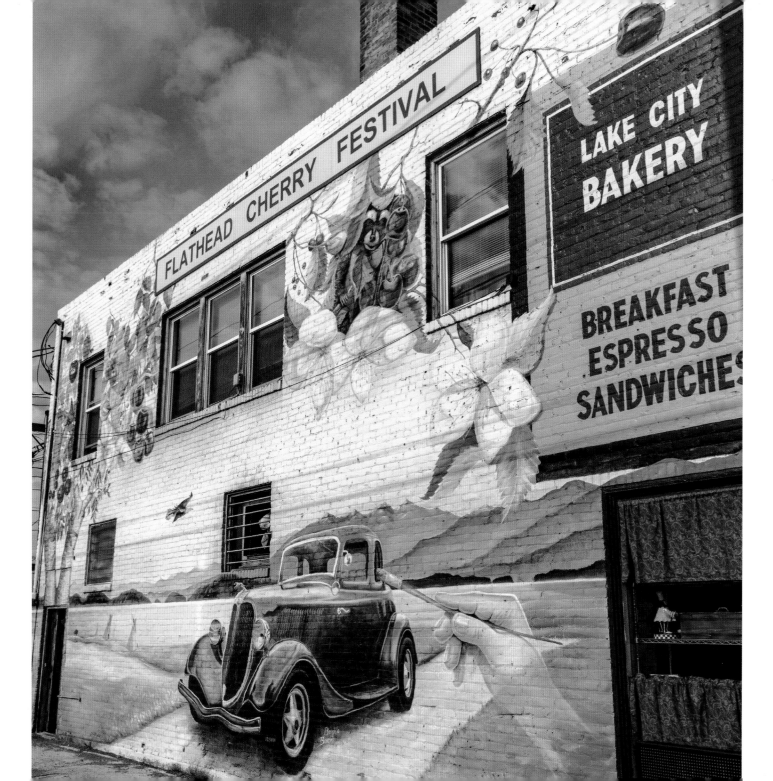

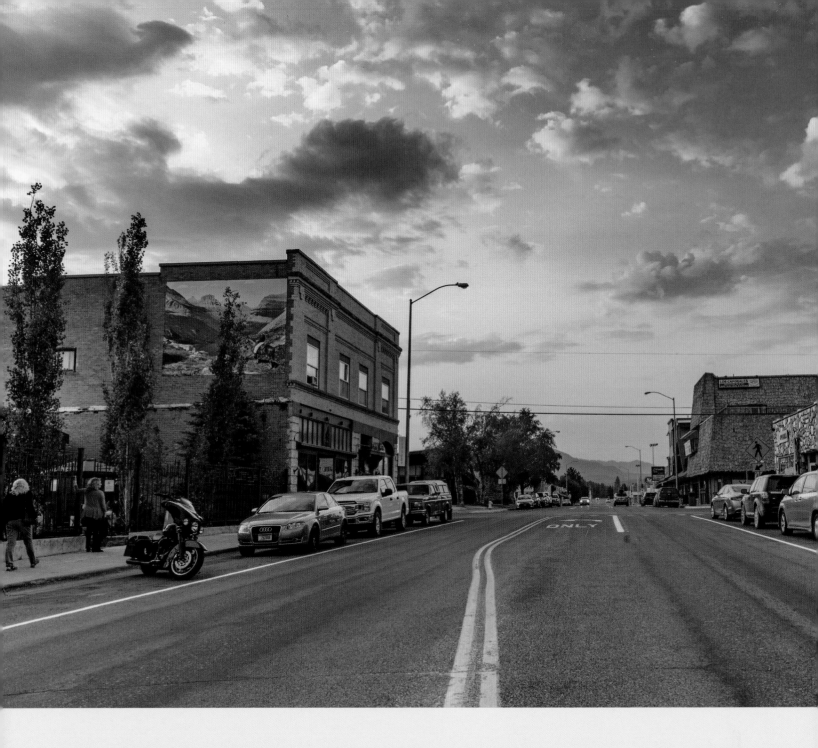

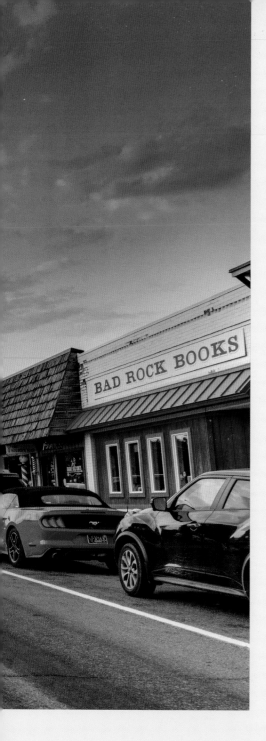

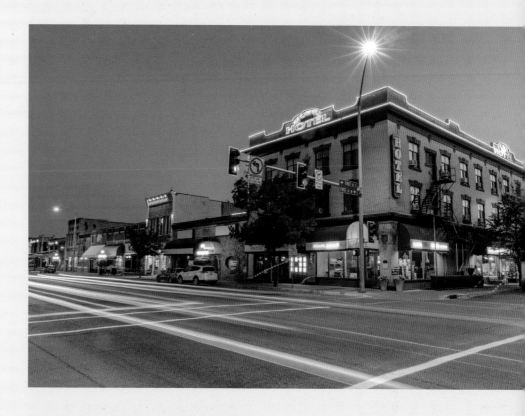

Above: Since 1912, the historic Kalispell Grand Hotel has welcomed guests. The hotel was completely restored in 1991.

Left: Tiny's Tavern in the tiny town of Charlo is a good place to get some refreshment after a long day watching wildlife at the National Bison Range.

Far left: Once an industrial town, Columbia Falls is becoming home to the outdoor enthusiast with its close proximity to Glacier National Park and the Flathead National Forest as well as the Flathead River, which borders the length of the city. Here is Nucleus Avenue, the town's main drag, at dusk.

Right: In the more arid regions of the Flathead, a fencepost is the highest perch for a red-tailed hawk to hunt from. The red-tailed is one of the most common hawks in North America.

Far right: Spring rains and snowmelt result in huge gardens of wildflowers at the National Bison Range. The range is also home to bighorn sheep, mule deer, pronghorn antelope, and elk.

Below: A herd of bison cross Mission Creek in the National Bison Range. The 19,000-acre range is completely fenced to keep the 350 to 500 bison that live there from roaming too far.

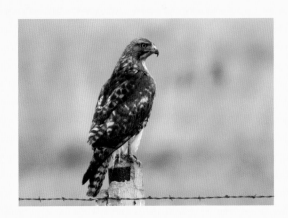

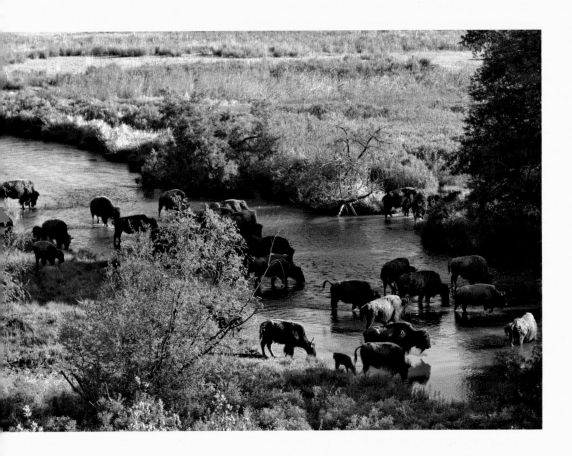

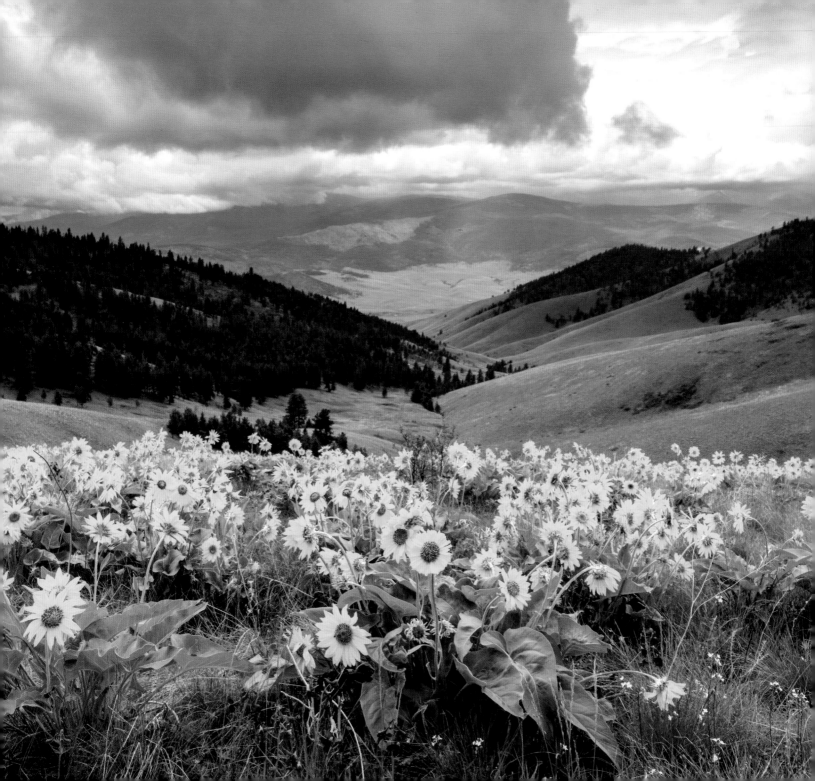

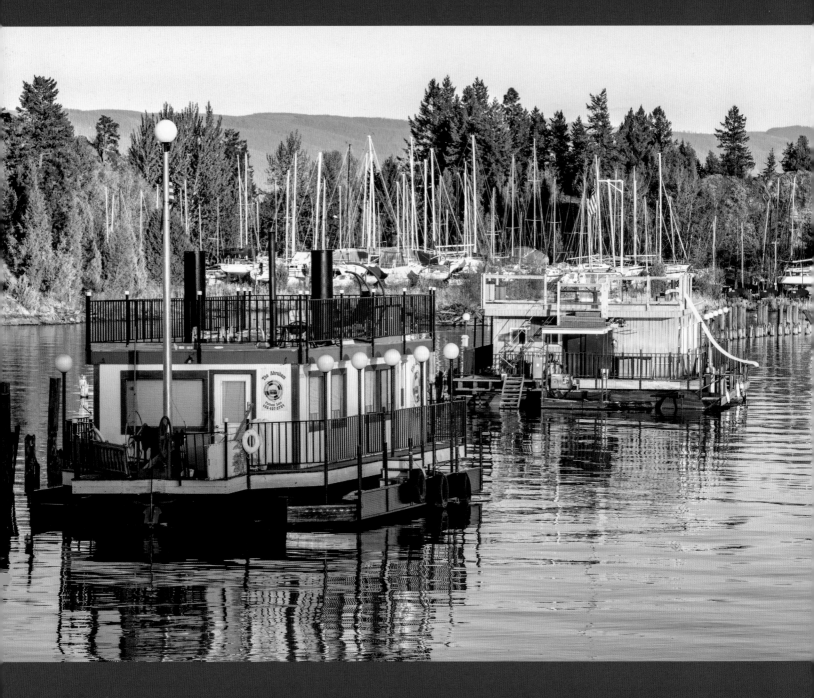

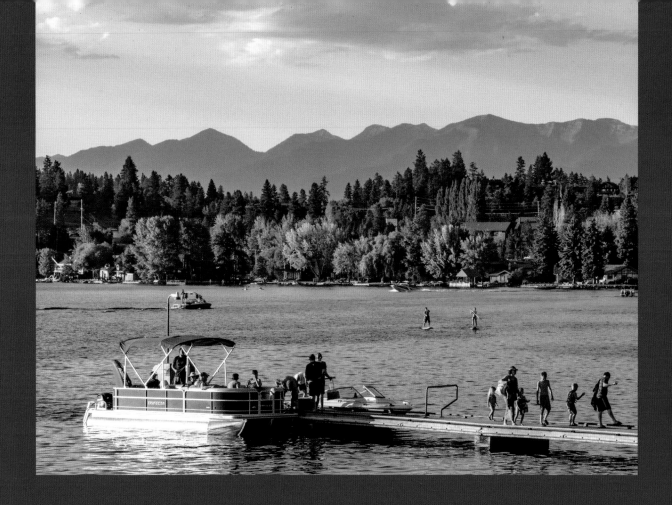

Above: Folks flock to Flathead Lake to cool off and have fun in the summer months. Public access to the lake is abundant, as the state maintains six parks on its shores as well as other fishing access points.

Left: A research vessel with supplies leaves the Flathead Lake Biological Station, one of the West's preeminent freshwater research facilities.

Far left: Some folks reside on Flathead Lake in houseboats, like these floating homes in Somers Bay.

Right: Ice fishing is a winter pastime in the Flathead Valley. An angler on a slough outside Kalispell shows off his catch.

Far right: The Flathead River is a mirror to the Swan Range on a frosty winter evening. The river takes on a slower and meandering personality as it nears Flathead Lake.

Below: Get in a little winter exercise Montana-style by skating on the ponds at Woodland Park in Kalispell. Skating is a popular winter recreation in the valley. If a pond or lake freezes just right, the ice is so clear you can see the bottom and the fish swimming below.

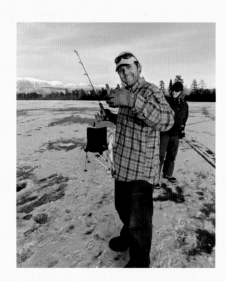

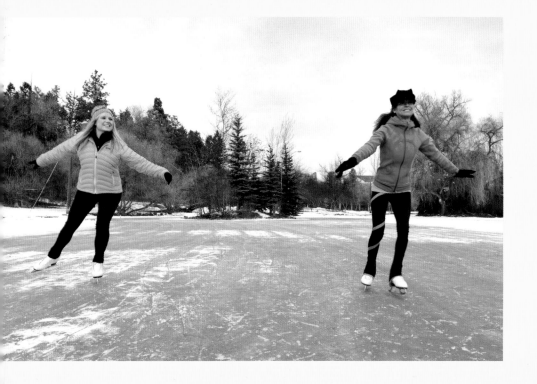

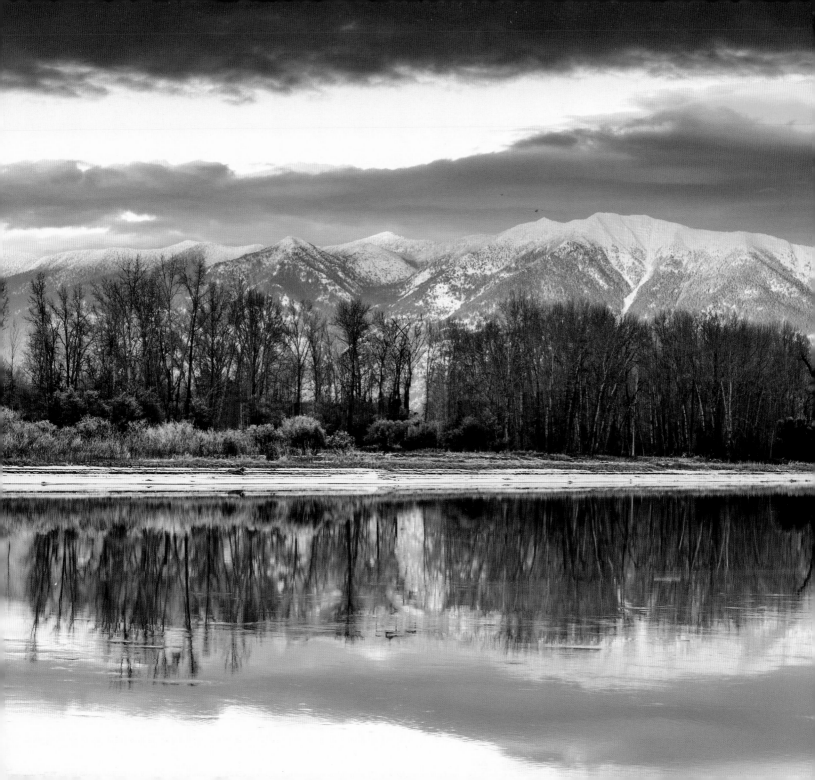

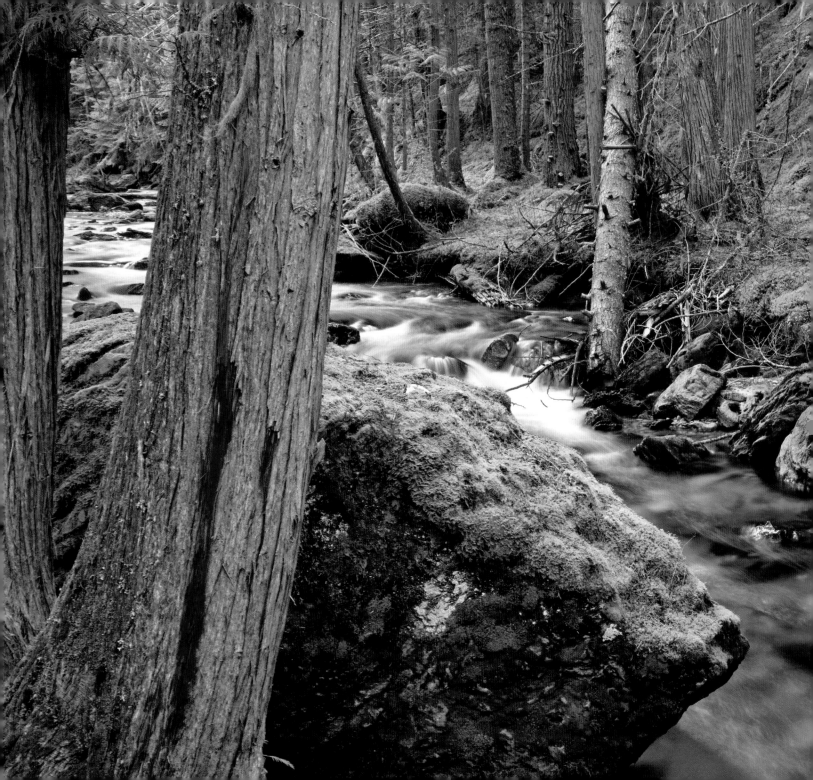

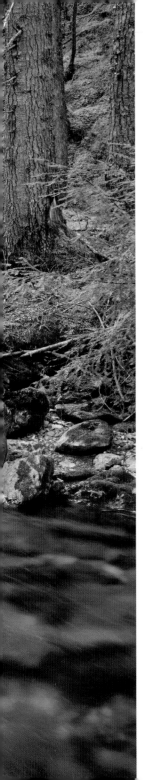

Left: Thoughts of pies and ice cream mount as huckle-berries ripen in the Flathead's forests. The huckleberry is a truly wild bush; attempts to cultivate the berry commercially have seen little success.

Far left: Mission Creek races through a forest of cedar and hemlock. The mountain ranges of the Flathead mark the eastern edge of the cedar's range. The largest trees in the valley grow in the McDonald Creek Valley of Glacier National Park and are at least 500 years old.

Below: Lupine, the purple flower, and Indian paintbrush, the red flower, bloom in the late spring and early summer. Paintbrush are hemiparasites, meaning they have the ability to take nutrients from other plants growing nearby.

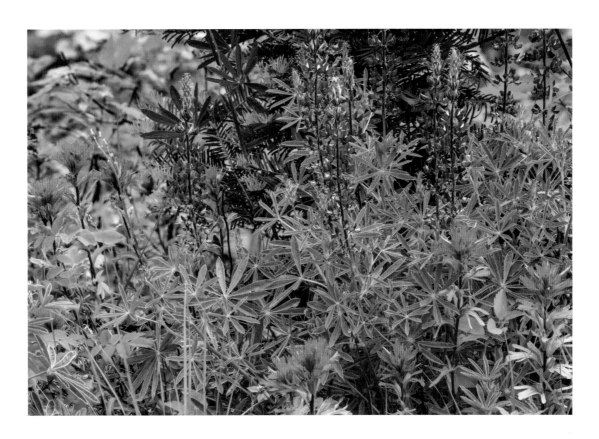

Right: A child makes a dandelion wish while hiking in the Flathead.

Far right: A starry night over camp on the Flathead River. With clear skies and little light pollution from cities, the region has superb night skies.

Below: Family fun while camping in the woods makes for lifelong memories. The Flathead is blessed with numerous campgrounds as much of the valley is public land, owned by the state, the Flathead National Forest, and the National Park Service.

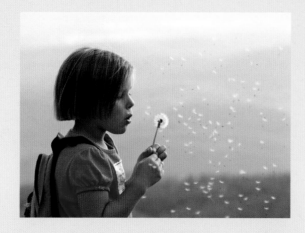

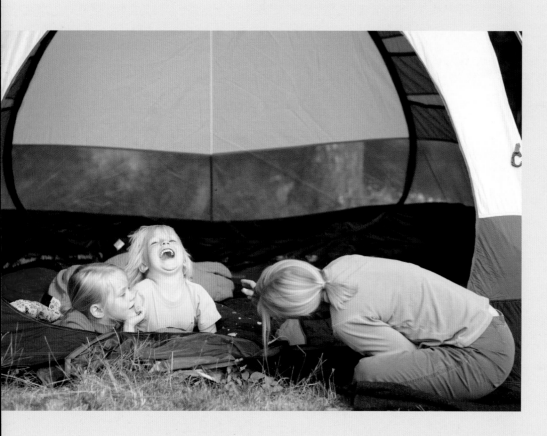

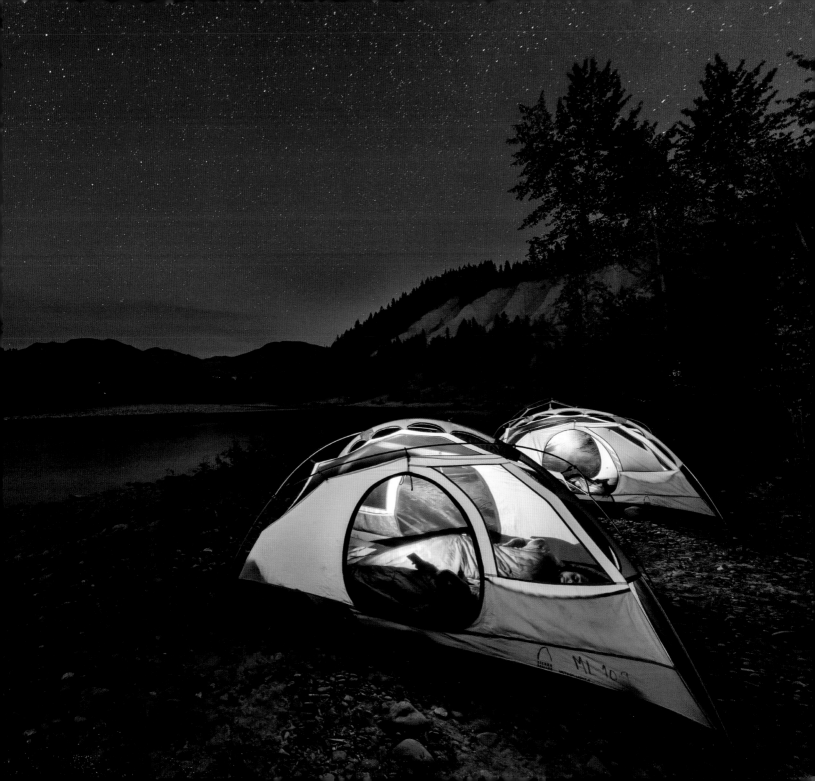

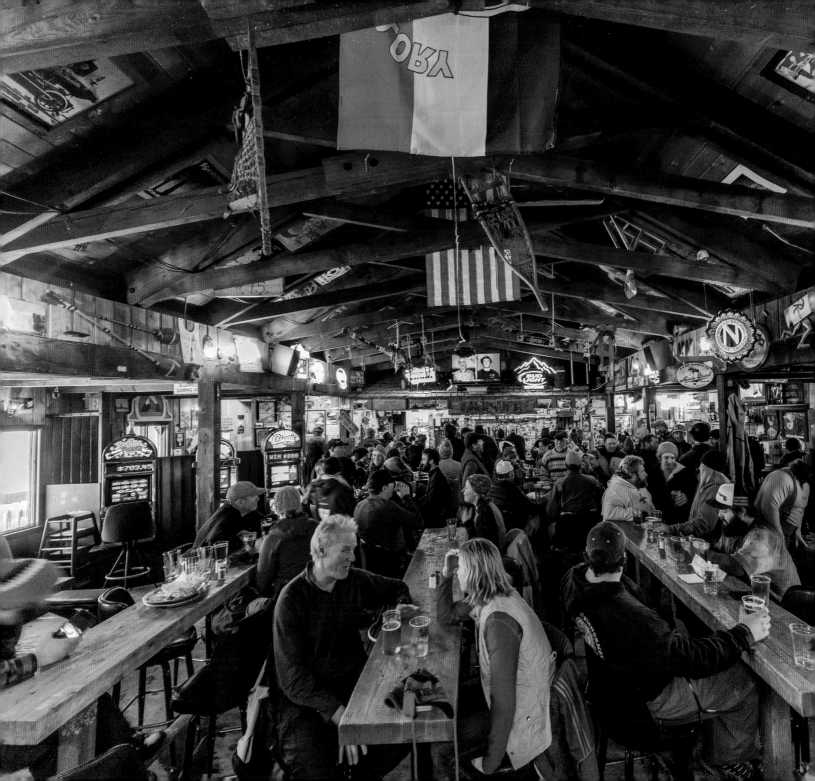

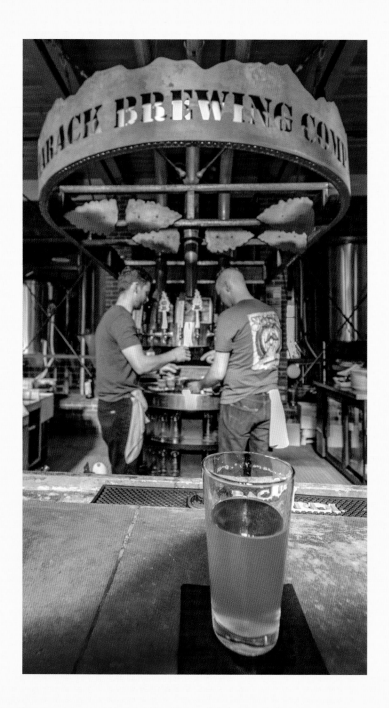

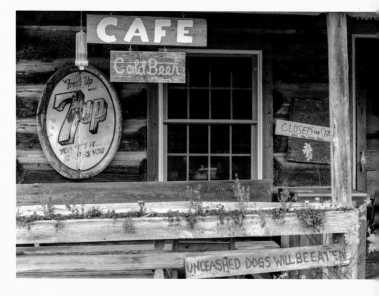

Above: The valley has no shortage of watering holes. The Northern Lights Saloon, however, is completely off the grid in Polebridge, about 35 miles up the North Fork of the Flathead.

Left: The Tamarack Brewery in Lakeside is one of several breweries in the Flathead Valley. The brewery has been making fine craft beers since 2007.

Facing page: After a long day on the slopes, the Bierstube at Whitefish Mountain Resort (aka Big Mountain) draws a crowd. The "Stube" as it's known, has a long and storied history. The original building burned down in 1963.

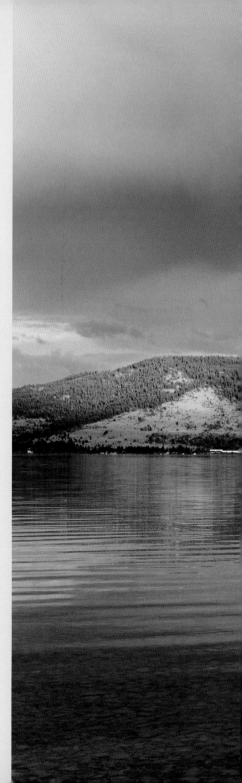

Right: A whitetail deer fawn pauses to groom itself. Summer living is comparatively easy for the region's creatures. Whitetail deer are extremely adaptive and do well in the farmlands as well as suburbs and cities of the Flathead Valley.

Far right: A rainbow arches over Flathead Lake near Elmo. The lake is 370 feet deep at its deepest point.

Below: A common loon with two chicks on a valley lake. The region is a bastion for the shy species, which raises its young on the fish-rich and secluded lakes of Northwest Montana.

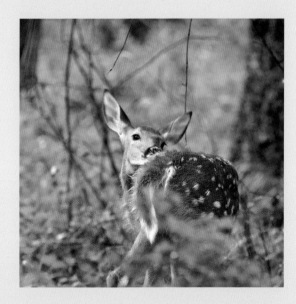

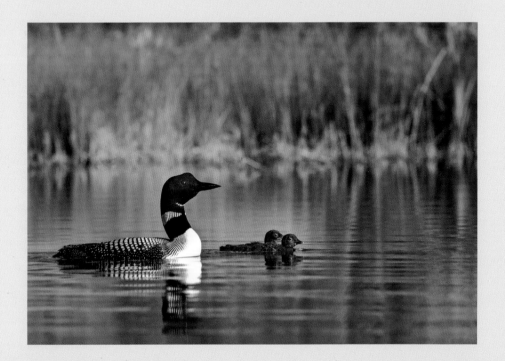

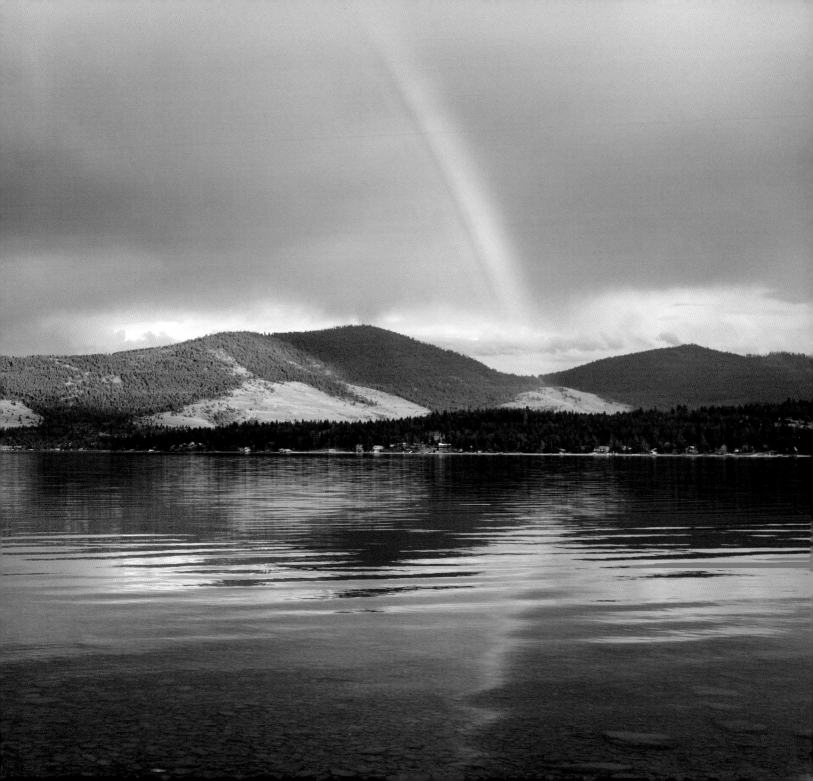

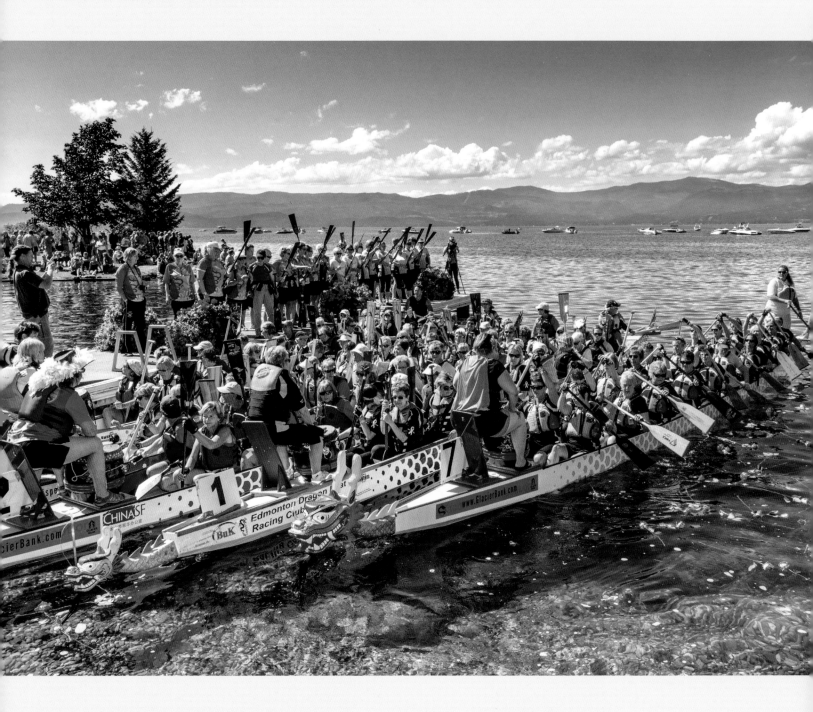

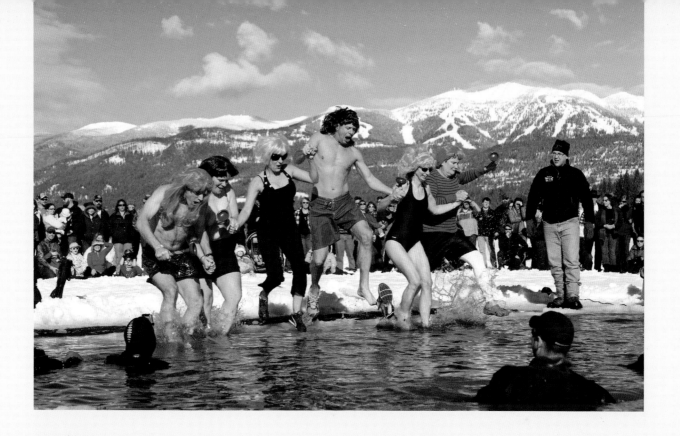

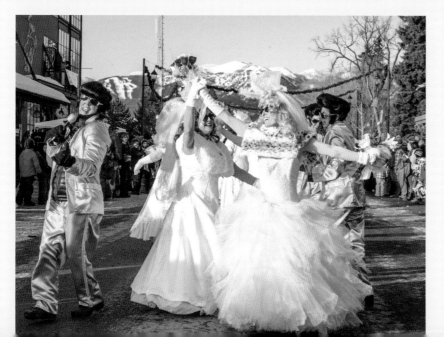

Above: The annual Penguin Plunge to raise funds for Special Olympics draws a host of bold folks, often in costume, willing to brave the icy waters of Whitefish Lake each February.

Left: The Whitefish Winter Carnival lightens the mood of a long Flathead February. The Working Women of Whitefish always have an entertaining take on life.

Far left: The Montana Dragon Boat Festival on Flathead Lake draws competitors from across the West every September. Here, participants take a moment to recognize loved ones battling cancer before starting a race.

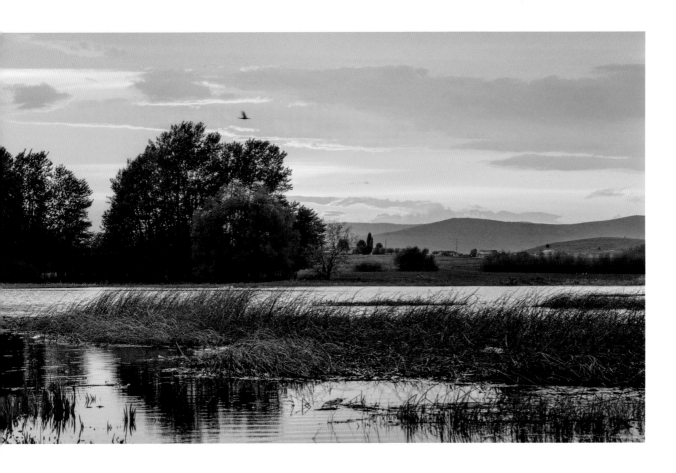

Above: The sun sets over the Pablo National Wildlife Refuge in the Mission Valley. The 2,500-plus acre refuge protects key waterfowl habitat in the valley.

Right: Western blue virginsbower is a native vine. Look for its distinctive flowers growing up the sides of trees and other plants from May to July.

Far right: Unlike most waters in the valley, the Whitefish River is a placid stream as it flows south through the valley to its confluence with the Stillwater River near Kalispell.

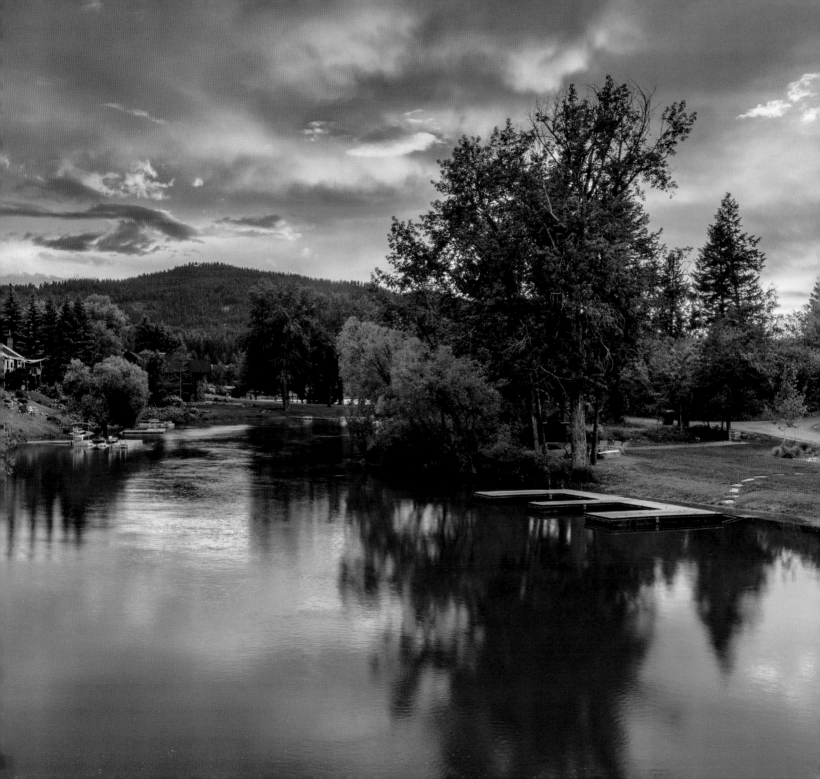

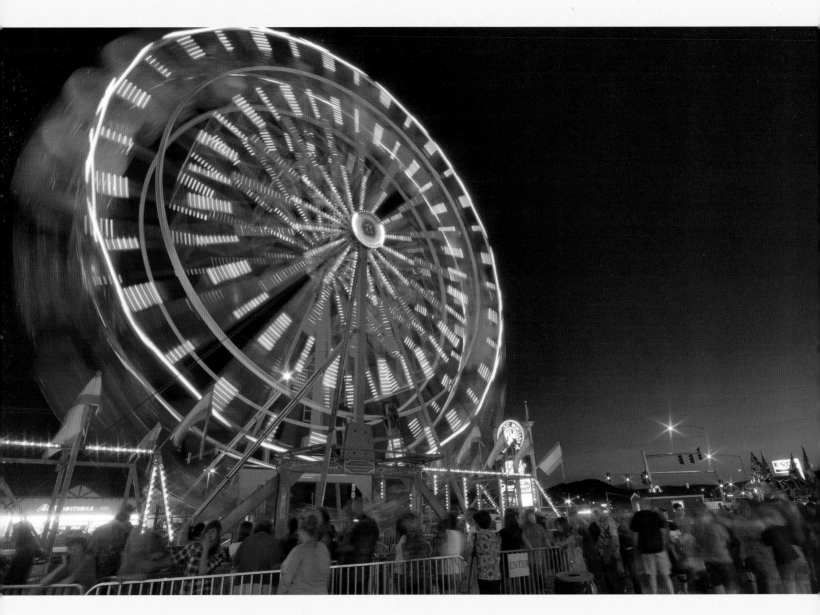

Above: The Northwest Montana Fair is one of the highlights of the summer in the Flathead Valley. Here, the crowd flows through the Midway on a pleasant summer evening as the Ferris wheel spins.

Facing page: A torchlight parade and fireworks greet the New Year at the Whitefish Mountain Resort.

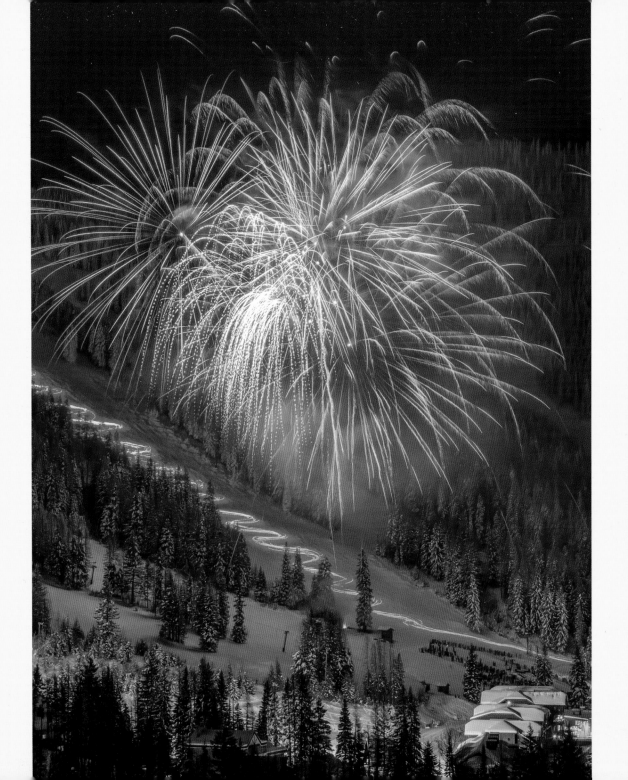

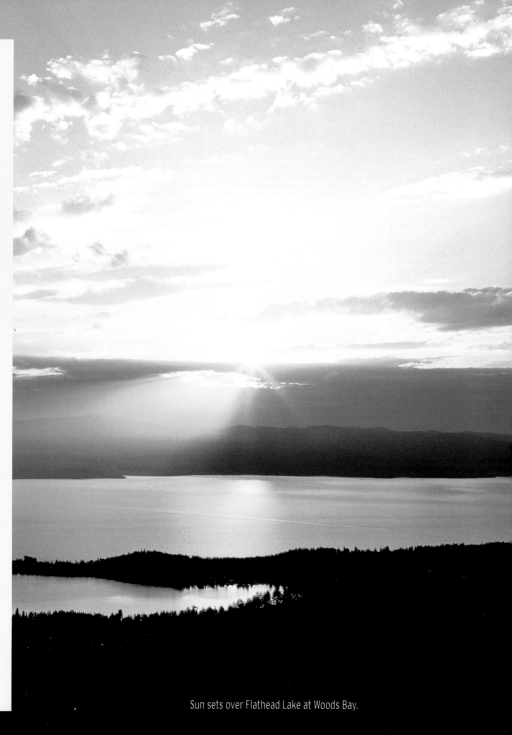

CHUCK HANEY is a professional freelance photographer and writer based in beautiful Whitefish, Montana. He travels extensively across North America in pursuit of the finest and most intriguing images. His provocative use of natural light in landscape, wildlife, and outdoor sports images has drawn national acclaim and has landed him many assignments, including advertising campaigns.

Chuck's finest images grace the walls of many residential and public spaces. His travel and outdoor lifestyle articles have been featured in numerous national and regional publications, adding to fifteen coffee-table books, over 200 magazine covers, and sole-photographer calendars to his credit. Chuck also enjoys teaching a series of popular photography workshops across the country each year.

To view more of Chuck's photography, visit his website at www.chuckhaney.com.

Sun sets over Flathead Lake at Woods Bay.